SeLF–
TAUGHT
GENiUS

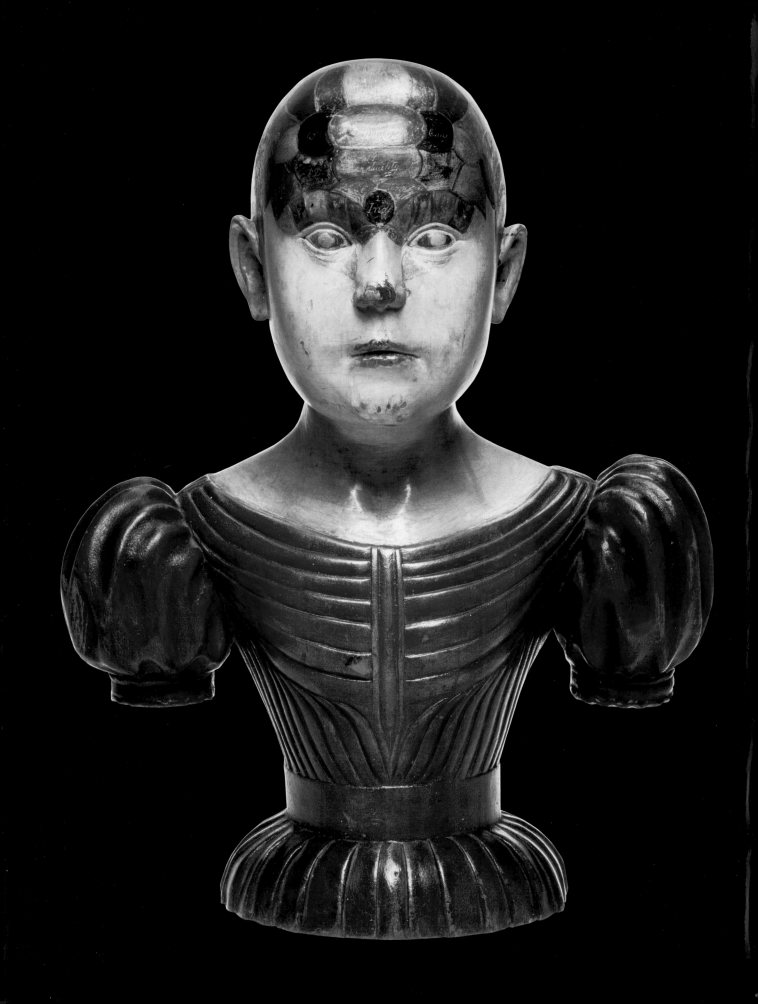

SeLF– TAUGHT GENiUS

TREASURES FROM THE AMERICAN FOLK ART MUSEUM

Stacy C. Hollander
Valérie Rousseau

With a Foreword by
The Honorable Anne-Imelda Radice

 AMERICAN FOLK ART MUSEUM
NEW YORK

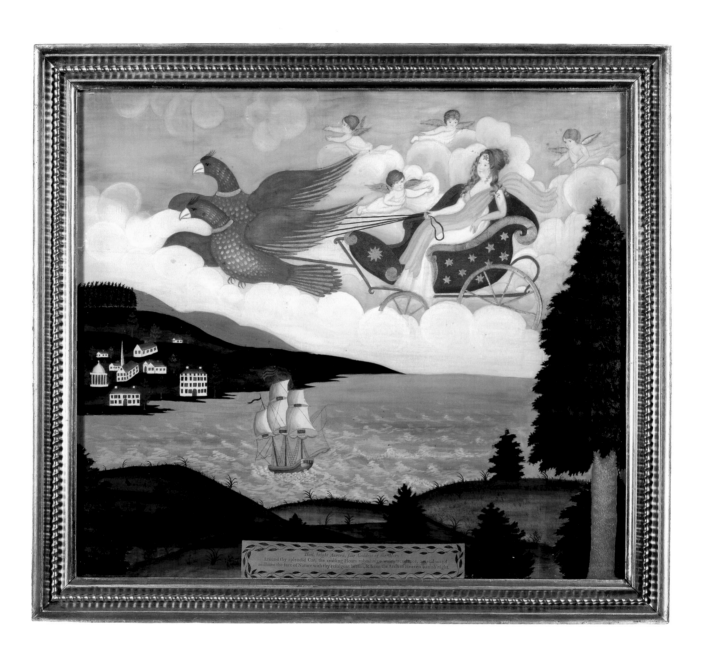

Hail, bright Aurora, fair Goddess of the Morn!
Around thy splendid Car, the smiling Hours submissive wait attendance, ascend — and
reillume the face of Nature with thy refulgent beams, & from the Arch of Heaven banish night.

SPONSORED BY THE HENRY LUCE FOUNDATION

With one of the premier collections of early American folk art and contemporary self-taught artists, the American Folk Art Museum has, for over fifty years, championed these great artworks that helped shape our nation's heritage.

Self-Taught Genius: Treasures from the American Folk Art Museum features more than one hundred masterworks that celebrate the singular power of folk art. Through a national tour, this exhibition and accompanying catalog will reach audiences across the country, expanding appreciation of both the museum and its signature collection.

Sponsoring the national tour epitomizes the Henry Luce Foundation's commitment to raising awareness of the scope and quality of American visual art. For some seventy-five years, the Foundation has fostered scholarship, innovation, and leadership—also attributes of the American Folk Art Museum. We are proud to support a national tour of their exemplary collection, which represents distinctive American creativity.

Michael Gilligan
President
Henry Luce Foundation

American Folk Art Museum
2 Lincoln Square
New York, NY 10023
www.folkartmuseum.org
www.selftaughtgenius.org

The exhibition, catalog, and national tour of *Self-Taught Genius: Treasures from the American Folk Art Museum* are made possible by generous funding from the Henry Luce Foundation, as part of its 75th anniversary initiative.

Frontispiece: *Phrenological Head*, Asa Ames (1823–1851), Evans, New York, c. 1850, paint on wood, 16⅜ × 13 × 7⅛", bequest of Jeanette Virgin, 1981.24.1

Page 4: *Aurora*, artist unidentified, New England, c. 1818–1822, watercolor on silk, with applied gold foil and paper label, in original gilded wood frame, 24⅞ × 28⅜ × 2¼" (framed), gift of Ralph Esmerian, 2005.8.46

Page 8: *Flag Gate* (detail), artist unidentified, Jefferson County, New York, c. 1876, paint on wood with iron and brass, 39½ × 57 × 3¾", gift of Herbert Waide Hemphill Jr. in honor of Neal A. Prince, 1962.1.1

Library of Congress Cataloging-in-Publication Data
American Folk Art Museum.
 Self-taught genius : treasures from the American Folk Art Museum / Stacy C. Hollander, Valérie Rousseau ; with a foreword by The Honorable Anne-Imelda Radice.
 pages cm
 Includes bibliographical references and index.
 "Published on the occasion of the exhibition Self-Taught Genius: Treasures from the American Folk Art Museum. The exhibition and catalog are organized by the American Folk Art Museum, New York."
 ISBN 978-0-912161-23-5
 1. Folk art—United States—Exhibitions. 2. Folk art—New York (State)—New York—Exhibitions. 3. American Folk Art Museum—Exhibitions. I. Hollander, Stacy C., author. II. Rousseau, Valérie, author. III. Title.
 NK805.A6827 2014
 745.0973'0747471—dc23 2014010665

Published on the occasion of the exhibition *Self-Taught Genius: Treasures from the American Folk Art Museum*, organized by the American Folk Art Museum, New York.

American Folk Art Museum
New York, New York
May 13–August 17, 2014

Figge Art Museum
Davenport, Iowa
November 15, 2014–March 15, 2015

Mingei International Museum
San Diego, California
April 18–August 16, 2015

Amon Carter Museum of American Art
Fort Worth, Texas
October 10, 2015–January 3, 2016

New Orleans Museum of Art
New Orleans, Louisiana
February 26–May 22, 2016

Saint Louis Art Museum
Saint Louis, Missouri
June 19–September 11, 2016

Tampa Museum of Art
Tampa, Florida
October 1, 2016–January 8, 2017

Produced by Marquand Books, Inc., Seattle
www.marquand.com

Edited by Tanya Heinrich and Megan Conway
Designed by John Hubbard
Typeset in Adobe Garamond Pro by Brynn Warriner
Proofread by Carrie Wicks
Color management by iocolor, Seattle
Printed and bound in China by Artron Color Printing Co., Ltd.

CONTENTS

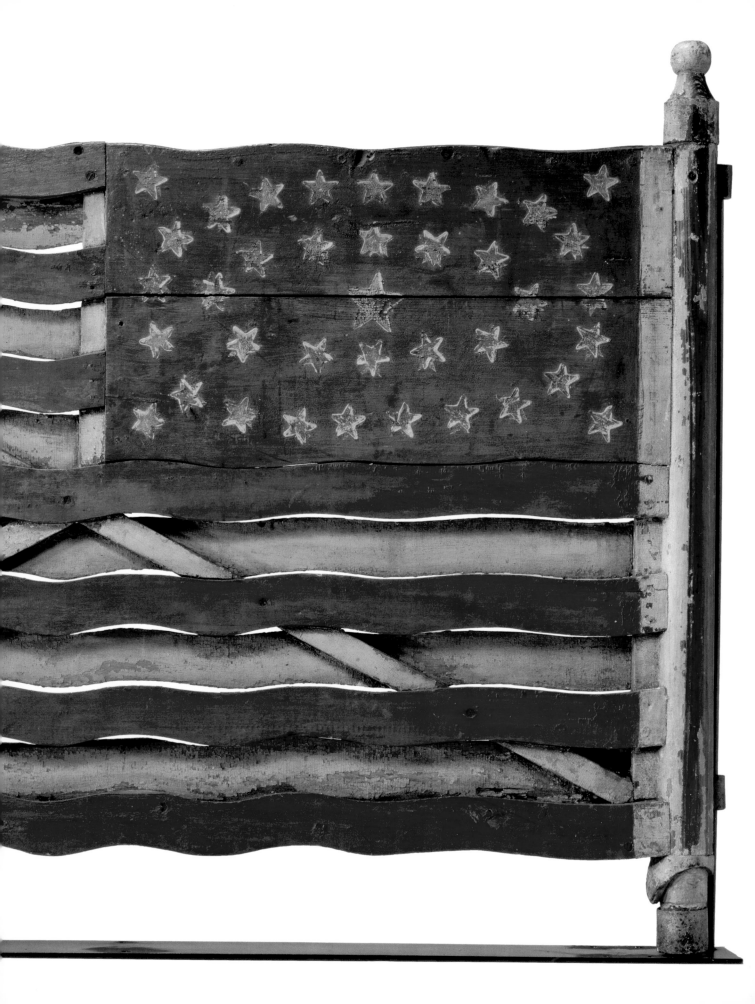

FOREWORD

The first exhibition of the American Folk Art Museum (then called the Museum of Early American Folk Arts) was held in 1962 at the Time-Life Building under the patronage of Mr. Henry Luce, Founder and Editor-in-Chief of *Time* magazine. What an honor it is to have the Henry Luce Foundation be the sponsor of *Self-Taught Genius: Treasures from the American Folk Art Museum* and its national tour. As this rich exhibition traverses the United States, we are keenly aware that Mr. Luce's initial support and his foundation have long stood by our museum.

To me the American Folk Art Museum is a national treasure that participates in the United States and internationally as an art and cultural leader. This exhibition demonstrates this claim in a unique manner.

I am certain Stacy C. Hollander, Deputy Director for Curatorial Affairs, Chief Curator, and Director of Exhibitions, and Dr. Valérie Rousseau, Curator, Art of the Self-Taught and Art Brut, had to make many difficult choices. However, their selections are masterful and the organization of the exhibition allows works from all eras to interact and herald different, yet important, themes.

I am honored to serve as the Executive Director and would like to especially thank Michael Gilligan, President, Henry Luce Foundation, and Ellen Holtzman, Program Director for American Art, Henry Luce Foundation, who have contributed singularly and mightily to the appreciation, care, and presentation of American art.

I would also like to recognize our wonderful Board of Trustees, led by Chairman Laura Parsons and President Monty Blanchard, as well as Vice President Joyce B. Cowin; and my hardworking colleagues at the museum, especially Elizabeth Kingman, Deputy Director for Administration and Development; Tanya Heinrich, Director of Publications; Ann-Marie Reilly, Chief Registrar and Director of Exhibition Production; Rachel Rosen, Director of Education; Karley Klopfenstein, Director of Institutional Giving, Strategy, and Evaluation; and Barbara Livenstein, Public Relations Manager.

In many ways this exhibition is dedicated to a remembrance of what has been achieved and the meaningful future that lies ahead for the museum.

The Honorable Anne-Imelda Radice, PhD
Executive Director
American Folk Art Museum

ACKNOWLEDGMENTS

We would like to acknowledge Dr. Anne-Imelda Radice, Executive Director of the American Folk Art Museum, for her support and dynamic leadership. We echo her gratitude to the Henry Luce Foundation for their unprecedented contribution to our museum and its curatorial vision. They have provided a rare and welcome opportunity for us to take a pause, reflect deeply, and share new directions for understanding and appreciating this complex and meaningful artwork.

Self-Taught Genius: Treasures from the American Folk Art Museum includes more than one hundred works by artists throughout the United States. The exhibition and this accompanying publication represent more than fifty years of institutional collecting. From the first gift of the *Flag Gate* in 1962 to the artworks most recently donated in honor of *Self-Taught Genius* by William S. Arnett and the Thornton Dial Family, Audrey Heckler, Carroll and Donna Janis, and Ron and June Shelp, the museum's collection has been formed almost entirely through the generosity of the many patrons who value the significance of this art and wish to see it cherished, protected, and shared. We thank all the donors, past and present, for entrusting the American Folk Art Museum with this precious legacy, and would like to acknowledge those whose donations have been selected for *Self-Taught Genius*: Judith Alexander; Amicus Foundation, Inc.; Gordon W. Bailey; Briskin Family Fund; Marijane Edwards Camp; Tom Conway; Creative Growth Art Center; David L. Davies; Adele Earnest; Ralph Esmerian; Estate of Martín Ramírez; Family of Dr. Max Dunievitz; Ralph and Eva Fasanella; Colette Auriti Firmani; Jacqueline Loewe Fowler; Abby and B. H. Friedman; Galerie St. Etienne; Millie and Bill Gladstone; Lewis and Jean Greenblatt; Sally and Paul Hawkins; Herbert Waide Hemphill Jr.; M. Anne Hill and Edward V. Blanchard Jr.; the Hirschhorn Foundation; Thomas Isenberg; Jean Lipman Fellows; Elizabeth Ross Johnson; Alice M. Kaplan; Evelyn and Leonard Lauder; Jerry and Susan Lauren; Kiyoko Lerner; Howard and Jean Lipman; Frank Maresca and Roger Ricco; Paula Nadelstern; Mr. and Mrs. Francis Fitz Randolph Jr.; Richard Coyle Lilly Foundation; John and Margaret Robson; Chuck and Jan Rosenak; Freyda

Rothstein; Charles and Eugenia Shannon; Barbara Blank Shapiro; Siegman Trust; Sanford and Patricia Smith; Patricia L. and Maurice C. Thompson Jr.; Trustees of the American Folk Art Museum; Jeanette Virgin; Elizabeth Wecter; Thea Westreich and Ethan Wagner; George Widener; Katherine Amelia Wine; and one anonymous donor.

We are grateful to Sandra Bloodworth, Director of the New York City Metropolitan Transportation Authority's Arts for Transit program, who arranged the temporary withdrawal of *Subway Riders* by artist Ralph Fasanella from the Fifth Avenue/Fifty-Third Street subway station in New York City for the exhibition. At Marquand Books we thank Ed Marquand, Adrian Lucia, Jeff Wincapaw, Melissa Duffes, Ryan Polich, Leah Finger, and John Hubbard. And for new photography included in this volume, we are indebted to Gavin Ashworth and Adam Reich. At the American Folk Art Museum Lauren Arnold, Deputy Registrar and Rights and Reproductions Coordinator, and Megan Conway, Managing Editor, helped to navigate the publication, and our curatorial interns Claudia Grigg Edo, Katherine Jentleson, and Alexandra Rozansky provided invaluable research assistance.

We would finally like to recognize the unique artistic contribution of the artists included in the exhibition, with a special mention of those who are still actively creating: Thornton Dial, Lonnie Holley, Paula Nadelstern, Melvin Way, and George Widener.

Stacy C. Hollander
Valérie Rousseau, PhD
Exhibition Curators

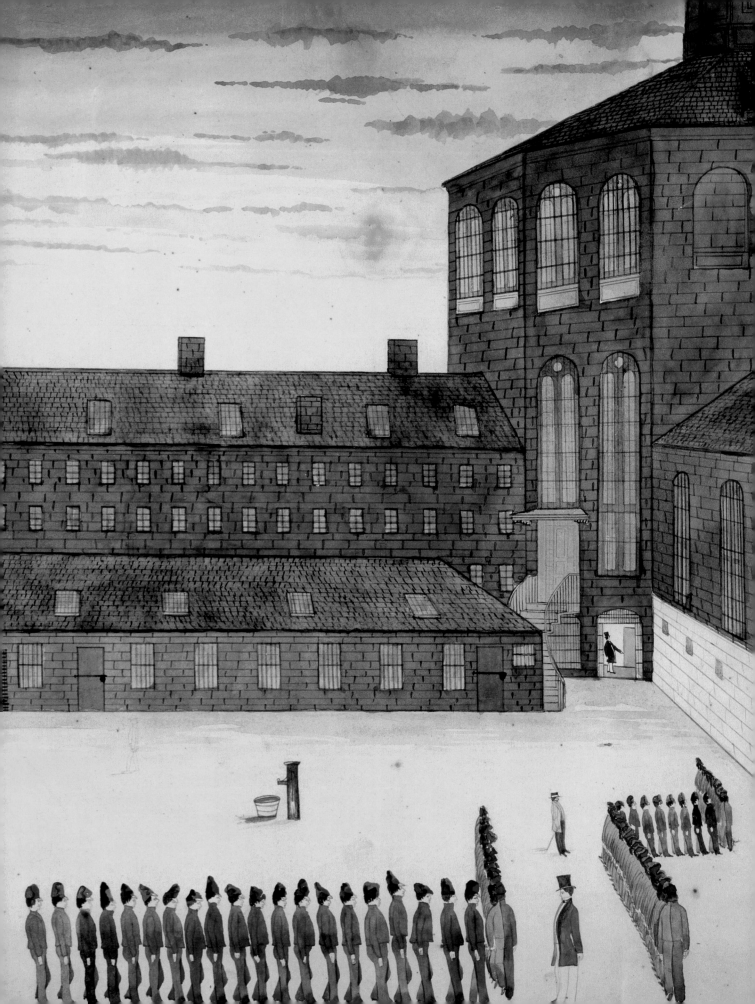

BREAKING THE RULES OF ART
Genius and the Emergence of the Self-Taught Artist

Stacy C. Hollander

Self-Taught Is a Methodology, Genius Is the Soul

On September 3, 1711, Joseph Addison (1672–1719), man of wit and taste and renowned English essayist and playwright, wrote in the *Spectator* (London) of "great natural Genius's . . . that were never disciplined and broken by Rules of Art."[1] With these words Addison deftly altered the trajectory of a growing discussion about the nature of genius, instigated in part by the puzzle of literary giants such as William Shakespeare, whose startling genius could not be explained purely through classical models. Addison's was an early voice in the growing intellectual cabal intent on unlocking and taming the wellsprings of genius, whether a transcendent or supernatural entity or an internal and inexplicable ability, "from hitting a target no one else can hit, to hitting a target no one else can see."[2] This was accompanied by a deepening conviction that natural or original genius was truer than a genius built on precedent that risked mere imitation.

Addison and the generations of thinkers who followed initiated an alternative path for discourse about the nature of inspiration in art and literature, one that was based on a different set of criteria: from having genius to being a genius.[3] It is the legacy of this alternative path that is explored in the exhibition and publication *Self-Taught Genius: Treasures from the American Folk Art Museum* through artists and artworks whose original genius rests on the shoulders of this great debate and the confluence of movements and world-changing events it touched.

At the turn of the twentieth century, the field of American folk art was being formed by artists, critics, curators, dealers, and collectors who championed the artworks as exemplars of a forthright honesty of purpose and execution that was absent from mainstream art and that seemed to encode the very DNA of American experience. After more than a century of nationhood and achievement in areas of business, technology, and science, the anxious search for an authentic American art seemed to be finally answered

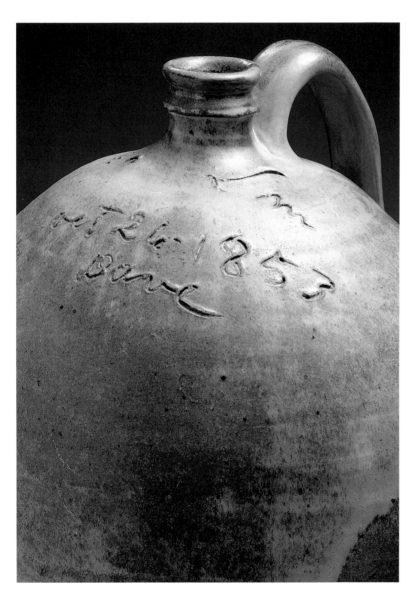

FIG. 2
Jug (detail)
DAVE DRAKE (C. 1800–C. 1870)
Lewis J. Miles Pottery, Edgefield
County, South Carolina
1853
Alkaline-glazed stoneware
14½ × 12 × 11½"
Gift of Sally and Paul Hawkins,
1999.18.1

in disarmingly sincere works that simply seemed to state: I am what I am. The unmediated directness of the art was the thing, from a slip-decorated redware plate that spoke to generational transmission of artisanship and culture to the unblinking portrait of a farmer that reflected society at face value. At the time, the artists themselves were largely unidentified, but the artworks nevertheless presented a compelling and multivalent story of evolving national identity, faith, community, struggle, triumph, humor, invention, originality, and individuality. What was not then recognized is that this intentionality served much the same function, in all its manifestations, at the moment the art was made, whether it was a colorful ink fraktur drawing of *Laedy Waschington* (Fig. 3) rendered in ornamental style by an unidentified eighteenth-century Pennsylvania-German artist or an antebellum slave-made jug with the artist's name, "Dave," bravely incised into the wet clay body (Fig. 2).

As the field continued to mature and its parameters were extended to include artists working in the present, scholars struggled to reconcile the variety of expressions and circumstances of creation now gathered under the umbrella of folk art. More recently the term "self-taught" has come to specifically address modern and contemporary visionaries working without the net of academia and finding their own ways through a maze of unorthodox creativity.[4] Folk art has continued to serve as a descriptor for early artistic production, a term that in the twenty-first century now has the passage of time, tradition of usage, and history on its side.

In the meantime, the enthusiastic reception of contemporary works by self-taught artists has extended beyond the original circle of appreciation, and there is a growing sense that this art represents a different trope in American visual culture, one whose connection to traditional folk art is increasingly difficult to articulate, especially to those not intimately familiar with the history of the field. The American Folk Art Museum maintains an unwavering conviction that this art we love, which is created in the trenches of life and not in the halls of the academy, is all part of the same great American narrative. However, for the field to advance as a single tale with many chapters, the words must be found to tell that story.

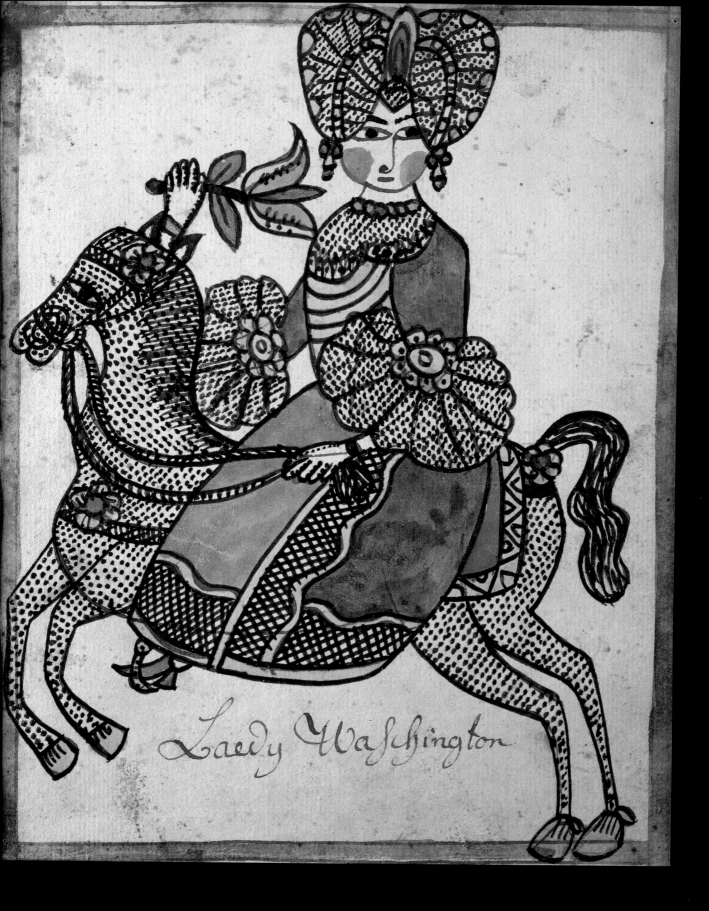

Laedy Washington

Self-Taught Genius proposes a new conversation, one that frames the continuum of American folk art through the concept of "self-taught genius," an elastic and enduring term with profound implications that, like the artworks themselves, has changed dramatically over time, from the eighteenth century to the present. The roots of "self-taught" and "genius" both lie in the very beginnings of artmaking in the United States: the early American folk art we so admire today was made by the self-taught artists of the past.

The idea of "self-taught" in America is entrenched in a culture of self-actualization that was fundamental to the revolutionary temperament and critical to the growth and success of a new nation. To understand the special place the term holds in American experience, one must first trace its path from the genesis of genius in Europe and the principles of the Enlightenment to the development of American identity and the connotations of the term today.

I n the early eighteenth century, questions about genius initiated a hotly contested—and somewhat personally competitive—war of ideas among men of letters in England, Scotland, France, and Germany. Was genius God-given or inborn? A state of being, a talent, a function of scholarship, or a psychological phenomenon? The new lines of thought represented a seismic shift from ancient notions of genius as a heavenly gift or an external genie or daimon—a kind of spirit guide that influenced thought, creativity, and behavior. In this physiological construct, is the daimon the id? The chaotic and creative facet of self? Jiminy Cricket?[5]

The psychological aspect of genius was approached by Anthony Ashley Cooper, third Earl of Shaftesbury (1671–1713), around the same time that Addison offered his thoughts on natural genius. In his celebrated *Soliloquy* (1710), Lord Shaftesbury proposed that we are all divided selves, and advocated using these separate mental "partys" as tools for critical self-examination.[6] He wrote of the "self-dissecting" nature of genius, offering the act of soliloquy as a vehicle to ponder a decision or action from multiple perspectives,

weighing the pros and cons and thus ensuring a measured outcome. He further considered these facets of self, describing them as aspects of genius, whether they denoted a natural capacity or a rare "forward genius" that brings forth an original outcome. In promoting self-knowledge as an analytical component, he anticipated poet and theologian Edward Young's (1681–1765) adjuration in his seminal epistle, *Conjectures on Original Composition* (1759) to "know thyself, reverence thyself," before original genius can "rise . . . as the sun from chaos."[7] Young retained something of the language of theology when he also located the source of genius in the heart and mind of the individual as that "God within."[8] Lord Shaftesbury's *Soliloquy* was widely read in Europe, and also by the intellectual elite in the American colonies. Benjamin Franklin, America's foremost self-taught genius, counted *Soliloquy* as one of the important treatises in his own process of self-education.

The premise that honest analysis of one's motives results in moral outcomes further influenced philosophers throughout the century, providing some part of the basis for faculty psychology—the idea that each human being has a set of potentials that can be realized through a vigorous and directed program of self-knowledge and self-improvement. Faculty psychology developed as a key element of the Scottish Enlightenment and was to play a major role in the formulation of the American ideal. Franklin had already instinctively applied much of its practical approach to moral philosophy in his own life. An inveterate list maker, he logically identified a problem, faced it head-on, and sought a virtuous solution in the no-nonsense manner that came to be associated generally with the American character.

Discussions of genius—natural, original, self-taught—became integral to two of the major movements of the eighteenth century, Romanticism and Enlightenment, and assumed national characteristics that tied authenticity of self to specificity of place—geography, culture, the very air that was breathed. In liberating genius from God and classical precedent, by placing it within the life spark of man, these ideas opened the possibility for freedom of self and individual. The ensuing revolution in philosophical theory laid the foundation for revolution in reality, first in the American colonies, then in France.

Perhaps the figure who best expresses the prickly complexity of the self-taught original genius is Jean-Jacques Rousseau (1712–1778), whose own conflicted personality often seems counter to his lucid and prescient writings. Rousseau was possibly the single genius of the Enlightenment who allowed his flawed humanity to inform every aspect of his intellectual thought through a surprisingly modern engagement in self-examination.

Rousseau's writings, especially his autobiography, are in essence "self-dissecting" soliloquies, his strengths and weaknesses fully exposed—even flaunted—to public scrutiny, humiliation, and censure. Assessing his moral and immoral actions over the course of a lifetime, Rousseau pondered why he learned easily when lessons followed his own natural inclinations but resisted when they were forced on him, why petty personal injustices caused him to rebel against social inequality and repressive government, and how these internalizations of his own peculiar behaviors and history seemed to reflect larger humanitarian truths. Each of these separate contemplations resulted in fully formed treatises that were dangerously at odds with contemporary thought, and that reflected the author's growing belief that the interests of the many were best served by being true to one's natural self.

Rousseau's letters and publications, based on this interior monologue with his own very human nature, presaged future ideas and events with a startling accuracy. He embodied Walt Whitman's cry of selfhood, "Do I contradict myself? Very well then I contradict myself, (I am large, I contain multitudes.),″ which is perhaps a defining trait of the self-taught genius in thought and in art.[9]

In an era of oppressive government, the attraction of a "natural" state of self-government was radical—and irresistible to the founders of the American republic that became an incubator for such ideas. While a decayed and exhausted Europe may have lost a sense of authenticity through its thick crust of civilization, America represented a *tabula rasa*, a fresh beginning containing infinite possibilities and incorporating precepts gleaned from Rousseau's political writings, the Scottish Enlightenment, and other theoretical movements well known to the Founding Fathers. From its inception, America

was viewed in psychological terms. The nation itself was tantamount to an original genius, having brought something new into the world: a self-government reliant on the vagaries of human self-interest and checks and balances between polis and elected representatives, and answerable to the essential values and needs of its citizens. Every participant in this new nation with no history was, in effect, a self-taught American.

The ethos that was stated in the Declaration of Independence bred a national character that encapsulated the tenets of the Scottish Enlightenment: virtue, industry, practicality, ingenuity, and self-improvement. Informed self-sufficiency—genius tempered by taste and self-discipline—was a major element necessary to the success of the enterprise: the self-realization of the individual benefited the society at large. Young Americans freely engaged in this process of self-definition. Eager to show both their independence from monarchical Europe and their conversance with European polite manners, they struggled with warring impulses between the rational and practical and the emotional and intuitive. The structure of the nation itself was essentially duplicitous. The Founding Fathers were largely an elite of highly educated, wealthy leaders, yet their vision of a republican union valued the self-determination of every individual and a shared set of values. Within this dichotomy, self-taught genius in America was free to subscribe to any interpretation that was most expedient.

Not surprisingly, the United States was immediately under close scrutiny, with expectations high and excoriations swift. The premise of self-taught genius was something of a protective coloring for a "start-up" nation with few established institutions, and that could not yet compete on a global scale. Thomas Jefferson expresses this defensive posture when he responds to criticism that no geniuses have yet to emerge from the grand experiment:

In physics we have produced a Franklin, than whom no one of the present age has made more important discoveries, nor has enriched philosophy with more, or more ingenious solutions of the phenomena of nature. We have supposed Mr. Rittenhouse second to no astronomer living; that in genius he must be the first, because he is self-taught. . . . We therefore suppose, that this reproach is as unjust as it is unkind; and that, of the geniuses which adorn the present age, America contributes its full share.[10]

The new nation turned "self-taught" into a virtue, a boast, and a powerful engine for moving forward. Americans in every field of endeavor seemed to prove the truth of Edward Young's words, "For what . . . mean we by genius, but the power of accomplishing great things without the means generally reputed necessary to that end?"[11] One very concrete way to illustrate the solidity of America's future was by immortalizing her prominent citizens. A style of portrait painting emerged immediately after the Revolution that patently rejected Europe's reliance upon classical conventions and associations and instead subscribed to a new, reality-based transparency. Depicting a state of original genius through luminous physiognomies with nothing to hide—no shades or shadows—America's men and women gazed clear-eyed and proud from canvases that situated them not in romantic, imaginary landscapes but in their own rooms with their own trophies of achievement and morality: books, furniture, property (Fig. 4). Such portraits conceptually supported the non-hierarchic values of an egalitarian society, even diminishing the interpolation of the artist through smooth, highly enameled surfaces.

Something of an informal patronage system developed, as elite citizens such as Ezra Stiles, president of Yale College, commissioned portraits and other works of art by self-taught geniuses. Stiles had Connecticut artist Reuben Moulthrop (1763–1814) paint his portrait on more than one occasion. Stiles's daughter remembered that he considered Moulthrop to be a "self-taught artist" who "pleased with his genius."[12] Moulthrop had served in the military during the War of Independence. A veteran, a patriot, and a

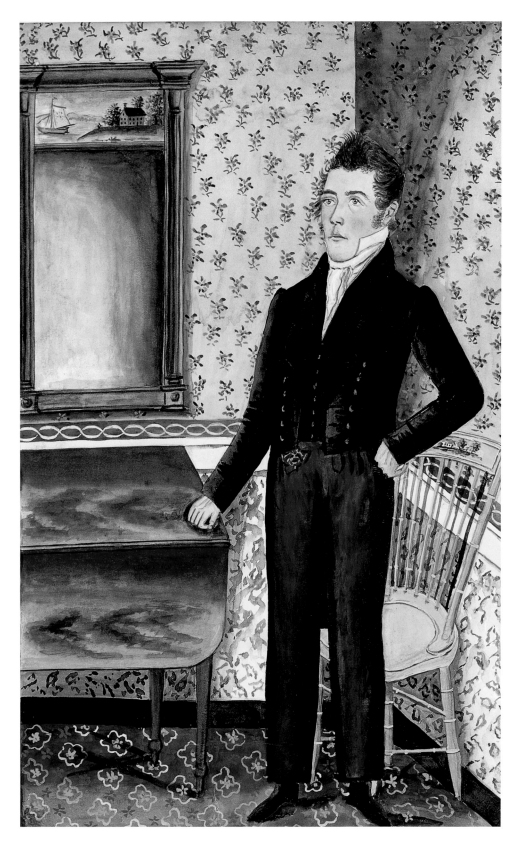

FIG. 4
Peter Zimmerman
JACOB MAENTEL (1778–?)
Schaefferstown, Pennsylvania
c. 1828
Watercolor, gouache, ink,
and pencil on paper
17 × 10½"
Gift of Ralph Esmerian,
2013.1.6

self-taught genius, he was celebrated in Connecticut, New York, and the West Indies for his life-size dressed wax figures staged in historical vignettes, none of which survive today. But he was also in demand for his dignified, unsparing, and impressive portraits of Connecticut's men and women of status.

The artists themselves were eager to assume the mantle of self-taught genius to tout their skills. In 1798 the portrait painter Joshua Johnson, a free black man in Baltimore, advertised his skills in the *Baltimore Intelligencer* as a "self-taught genius, deriving from nature and industry his knowledge of the Art."[13] In the particular wording of his advertisement, Johnson acknowledges an awareness of the benefit to be derived from an association with Enlightenment theories of genius and the approbation of innate talent in America. He further allies himself with the virtue of industry, propounded by Benjamin Franklin in the example of his own life, the aphorisms he published in *Poor Richard's Almanack*, and in the autobiography he published in 1791. By the turn of the century, a countermovement was already emerging that decried a willful pride in being self-taught as an artist—or the ignorant consumer of such art—rather than elevating skill and taste through a study of European art.[14] Nevertheless, "self-taught" continued to be used as a badge of pride rather than a condemnation.

Some traditional arts continued in production during and after the war much as they had before. The Germanic immigrant groups that settled in Pennsylvania drew upon a range of practices and traditions from their various homelands of Switzerland, Austria, Alsace, Prussia, the Palatinate, and numerous other regions of Europe. Though these communities comprised a wide range of religious faiths—Lutheran, German Reformed, and Catholic; Mennonite, Moravian, and Schwenkfelder; and several communal Pietist groups such as Ephrata Cloister—they maintained a strong cultural identity while actively interacting with and contributing to each area in which they settled. The greatest period of artistic production occurred from about 1770 to 1840. Local craftsmen—potters, cabinetmakers, carvers, weavers, metalworkers—provided utilitarian and decorative household wares, while schoolteachers, religious leaders, and others trained in the art of writing supplied

the handwritten and embellished documents known as fraktur. Though the retention of familiar techniques and forms, some learned through generational or master-apprentice relationships, attested to a deeply shared set of values and ideas, specific regional identities and responses to a wider American influence also developed over time.

Pennsylvania Germans participated in the war effort. One fraktur drawn by an unidentified artist testifies to the artist's pride in Philadelphia's role as the site of the First and Second Continental Congress. By inscribing in German "George Washington and the city that was built in his name," and the English words "Congress House" on the facade of an impressive government building, the artist expresses his dual heritage and conflates the removal of government from Pennsylvania to the new capitol of Washington, DC, and the establishment of Congress on Pennsylvania Avenue.

In a fledgling republic where only a small minority of the population was privy to a private education, there was an early recognition that for the country to grow and thrive, a course of self-education was necessary so that its citizens might become full contributors to its future. "Self-taught" became a widespread and endorsed culture that was endemic to American thought, spirit, and achievement, and that stemmed from the earlier arguments about genius and the development of faculty psychology as a tool for self-realization. Though little of this dialogue was directed at women in American society, a concomitant program of Republican Motherhood was something of a corrective. In the years following the Revolution, numbers of female academies and seminaries were formed with the primary purpose of educating girls so that they might grow into literate, moral, intelligent women capable of raising sons who would become the next generation of American leaders. Serious schools, notably the Litchfield Female Academy in Connecticut, offered ornamental arts such as needlework, drawing, and painting with watercolors, but combined them with rigorous academic studies that "ornamented the mind" as well, such as Greek, Latin, botany, history, geography, philosophy, and religion.

In 1788 Rebecca Carter stitched her testament to statehood in one such school operated by Mary Balch in Providence, Rhode Island. Her sampler highlights the classical architecture of the State House in Providence, at once attesting to the republican ideals of the nation and the development of its infrastructure through the establishment of august bodies of government. Lucina Hudson's father had fought in the war. Her needlework, made under the watchful eye of schoolmistress Abby Wright in South Hadley, Massachusetts, is a statement of American independence in the guise of the allegorical figure of Liberty, who nevertheless is fashionably dressed in the European mode of the day. The unanticipated by-product of Republican Motherhood was a golden age of artmaking by women, who expressed their genius—as well as their thoughts and opinions—primarily through needle and thread in samplers and pictorial needleworks, and also in quilts and other bedcovers that were, in fact, among the most monumental and freely expressive works of art of the day. Perhaps more than any other art form in America, quilts have been a consistent presence, distilling national moments through personal perspectives.

The earliest artists represented in *Self-Taught Genius* had either experienced the American Revolution firsthand or were of the first postwar generation. The strength of their belief in self-determination, and their resilience in the face of the exigencies of war and a dramatically shifting political-economic landscape, established the rugged individualism of the American character early and indelibly. John Hewson (1744–1821) was a highly trained British calico printer who arrived in America in 1774 with an intimate knowledge of textile printing technology and a letter of recommendation written by Benjamin Franklin, whose encouragement of mechanical genius was well known and who ardently advocated for equal opportunities of self-improvement for artisan tradesmen.[15] Hewson set up a successful printworks and bleaching yard in an area outside Philadelphia and advertised that he had patterns for "printing calicoes and linens for gowns, & c., coverlids, handkerchiefs, nankeens, janes, and velverets," defying the British mandate against domestic manufacture in the colonies.[16]

Hewson quickly had a price set upon his head and was captured by the British soon after joining the Philadelphia militia. He ultimately escaped, reestablished his print business, though in straitened circumstances, and was honored for his ardent support of American independence by representing the Pennsylvania Society for the Encouragement of Manufactures and the Useful Arts in the Grand Federal Procession that marked the ratification of the Constitution of the United States.[17] An early pieced quilt in this exhibition featuring a Hewson-printed center block speaks to the time when printing cloth and making quilts was a collusive act of defiance.

Winthrop Chandler (1747–1790) was one of the first American artists to visually engage with the landscape in a number of overmantels and portraits that he painted for relatives and neighbors in Connecticut and Massachusetts.[18] It was not until the American landscape was visibly improved that it became a subject of interest to landowners and the artists they commissioned to commit the land to posterity through overmantels and fireboards that adorned the central hearth of the home, or as glimpsed through windows in their portraits. In early American parlance, "improvement" involved personal betterment but also implied a moral imperative to develop one's faculties to full potential for the betterment of society. In landscapes, this meant altering a wild, original state of nature into one that was useful to man. The extant paintings by Chandler portray identifiable features of homeowners' buildings and properties. They sometimes also incorporate dramatic and melancholy elements—oversize trees with decaying limbs, for example—that show a conversance with the idea of the sublime, a theory that developed in tandem with the conversation about genius. One overmantel in the form of a trompe l'oeil shelf of books also indicates that Chandler was aware of the notion of fancy and imagination that was part of the aesthetic discussion of the day.

The overmantel Chandler painted for the home of his cousin John Chandler, in Petersham, Massachusetts, however, is something of an anomaly and seems to tell a different story—one, perhaps, that is more closely allied to the concept of original genius. The landscape in this overmantel is clearly stratified into three levels (Fig. 5). In the foreground

FIG. 5
Scenic Overmantel (detail)
WINTHROP CHANDLER
(1747–1790)
Petersham, Massachusetts
c. 1780
Oil on pine panel with beveled edges
29¼ × 47¼ × 1½"
Gift of Ralph Esmerian, 2013.1.20

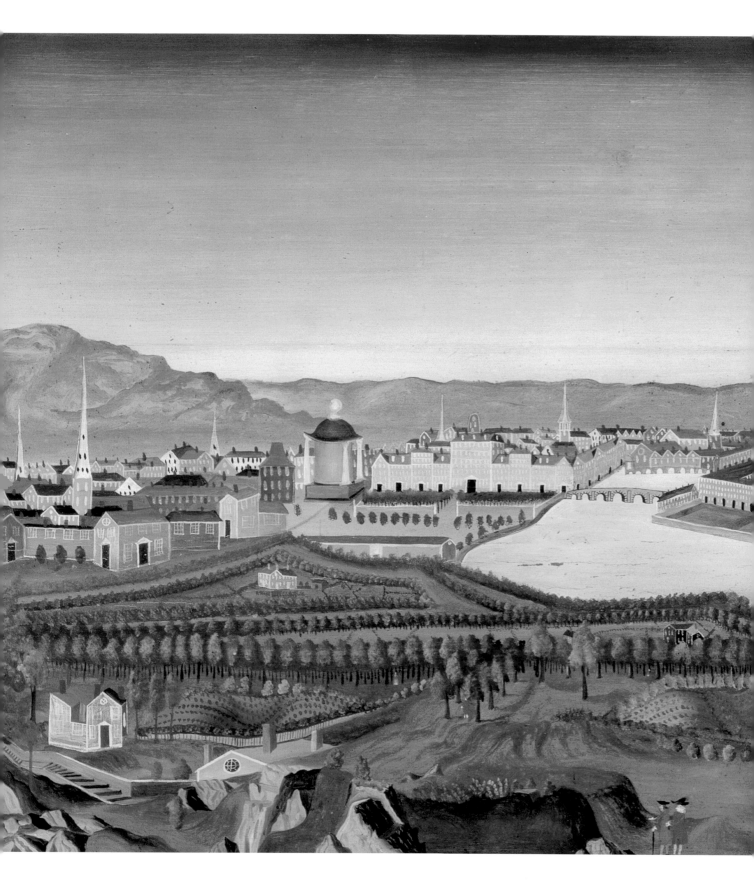

two gentlemen stand in a barren and rocky terrain, with inexplicable stepped paths. The middle ground is a neat arrangement of verdant plantings, laid out in geometric formality, while the distance features a startling Italianate landscape that evokes the city of Florence, a center of artistic flourishing during the Renaissance.

A metaphorical reading of this scene evokes the path of original genius described in Enlightenment writings by Edward Young, Alexander Gerard (1728–1795), and William Duff (1732–1815), all of whom used the language of landscape as a symbolic device to express their ideas.[19] The foreground is suggestive of Young's "barren waste" from which the "blooming spring" of original genius is to be wrested, and which lies far from the corrupting knowledge of what has already been conceived in the past.[20] The stepped path that appears and leads nowhere recalls the "mazes of error" described in Duff's *Essay on Original Genius* (1767). This is a false path that untempered imagination may be tempted to follow. In the evolution of genius described by the Scottish Enlightenment, inspiration might flourish amid the untrodden paths of a primeval forest, but it would fly into florid incoherence unless reined in by taste, perhaps signified by the "improved" landscape of the middle ground.[21] In this scheme, then, the Italianate scene in the distance would represent the brilliance of the classical world and the Renaissance to whose heights the contemporary genius might aspire, but which must be achieved through his own original thought.

One of the first artists to be collected by the early generation of folk art enthusiasts was Edward Hicks (1780–1849), a Quaker minister and artist best known for his many versions of the peaceable kingdom described in Isaiah 11. The theme of harmony among natural enemies is one that reverberated for Hicks, whose childhood was tragically disrupted by the war and whose adulthood was profoundly affected by an irrevocable break in the ranks of the faith he loved. Hicks was a child when his father was economically compromised because of his suspected Tory loyalties. Financially destroyed, ostracized by his community, and newly widowed, the elder Hicks placed

his young son in the Quaker Twining family to be boarded and raised, an idyllic period that the artist rendered in a series of memory paintings toward the end of his life. As a young man Hicks did a stint in the military, caroused, and lived in a rather dissipated fashion until he was apprenticed to an ornamental and sign painter and found a creative outlet to focus his restless spirit. He embraced the Quaker faith and became one of its most ardent adherents. But he struggled to reconcile the brilliant inner light with the worldly life he valued as an ornamental artist, which was in conflict with the tenets of his religion. His iterations of *The Peaceable Kingdom* became a powerful vehicle to negotiate between these two psychological poles and a means of coping with forces out of his control.

No such inner conflict existed for Shaker Hannah Cohoon (1782–1864) when she recorded a divine vision in *Gift Drawing: The Tree of Light or Blazing Tree* (Fig. 6), Cohoon had already retired from the "world" when she entered the Shaker community in Hancock, Massachusetts, in 1817. Vestiges of the transcendent nature of genius are retained in such images that were revealed to Shaker "instruments" by deceased Shaker leaders or sacred figures during a period of religious revival in Shaker history known as the Era of Manifestations. The images, received by prophetic vision, were subsequently recorded in inspired, visual form. The tree of light—or life—imagery would have been well known to Cohoon, who was twenty-nine years old when she became a Shaker. It was a major motif in American quiltmaking, needlework, and watercolor beginning in the eighteenth century. Cohoon recorded that her vision was delivered by an angel whom she saw "as distinctly as [she] ever saw a natural tree." This spirit guide moved Cohoon to create a glorious and moral representation that was received by her as a gift and would serve as a

FIG. 6
Gift Drawing: The Tree of Light or Blazing Tree (detail)
HANNAH COHOON (1788–1864)
Hancock, Massachusetts
1845
Ink, pencil, and gouache on paper
16 × 20⅞"
Gift of Ralph Esmerian, 2013.1.3

gift to inspire others. And in a practical aside on the verso, so typical of the dual nature of Americans in every walk of life, Cohoon cautions the recipient not to touch the paint as it might flake off in her hands.

In the decades following the Revolution, men who were self-educated, self-improved, and self-defined increasingly wanted documentation of their achievements through the vehicle of portraiture. The artists they turned to emerged naturally from their own ranks of self-realized Americans whose limits were set only by the extent of their own talents and the guidance available to them. Such artists were either entirely self-taught, had received a course of practical training as ornamental or sign painters, or were the benefactors of the many instructional pamphlets, publications, copy books, and drawing cards that proliferated in a calculated campaign to convince the practical American populace "that art was, in fact, a sign of political health—so long as art was presented as useful rather than only beautiful."[22]

It is not known what training, if any, the portrait painter Ammi Phillips received. Artists such as Phillips developed their skills primarily through apprenticeships or their own self-directed applications. Genius—if they possessed it—broke through the chaos in what Joseph Addison described as "Works that were the Delight of their own Times and the Wonder of Posterity."[23] Certainly nothing short of genius could account for the wonder of the portrait Phillips painted around 1830 of a young girl wearing a red dress and holding her white cat in her arms. His earliest extant efforts, though, were raw enough to suggest that he honed his skills largely through his own industry, though he confidently advertised from the first that he would offer a money-back guarantee if the recipient was not pleased with his portrait.[24] Around 1812, at the beginning of Phillips's career, he painted a portrait of publisher Ashbel Stoddard, whose *New York Hudson Gazette* was founded as a paper "conducted upon truly republican principles and which shall ever be the watchful centinel of its liberties."[25] In his portrait Stoddard holds a folio of George Washington's *Farewell Address*, an edition of which he had published in 1797 (Fig. 7). The artist was eleven years old when Washington died, in 1799, perhaps the first momentous

event of shared national experience other than the declaration of independence itself. Phillips also portrayed Stoddard's wife, Patience, who conspicuously holds a book with the spine facing out so that the author might be identified as Edward Young. The artist, no less than the sitters, was thus a complicit collaborator in forming a picture of Mr. Stoddard's mechanical genius as a publisher, his informed political sensibilities, and his wife's literate conversance with original genius and the niceties of European polite thought and taste.

Phillips was born in 1788, around the time the U. S. Constitution was ratified. His lifetime spanned the first generation of Americans and their dream of *e pluribus unum* through the end of the Civil War and a divided country. His life experience commenced with presidents elected from among the Founding Fathers and closed with the installation of two presidents, Andrew Jackson and Abraham Lincoln, who were self-taught and

FIG. 7
Patience Bolles Stoddard
Ashbel Stoddard
AMMI PHILLIPS (1788–1865)
Hudson, New York
1812–1813
Oil on canvas
29 × 24¾" each
Courtesy Joan R. Brownstein
and Yost Conservation, LLC

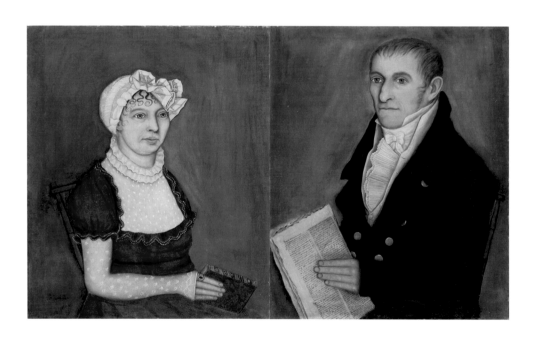

self-made men. The great shift in leadership from the wealthy intellectual elite to men who had distinguished themselves through only their own efforts and native talents reflected an even greater shift in society at large, from polite society based on a rural agricultural economy to a brasher urban culture based on industrial innovation. Phillips continually adapted his portraits, from the Romantic age of genius to the looming rift of the Civil War era, to reflect contemporary taste, but he never lost sight of the basic values espoused in even his earliest works. Minimal, direct, and true, the portraits do not privilege foreground or background—the figures inhabit the same plane as the ether around them. Instead, a light always shines on the face of the sitter, maintaining a stasis between man and nation even as the union was faced with the specter of war. Throughout his decades-long career, Ammi Phillips continued to find the essence of the individual in portraits whose beauty is timeless and whose humanity is universal.

One of the few American artists who started as a self-taught painter of shop signs and rose to paint members of the British nobility, even without the benefit of a European training, was Massachusetts artist Chester Harding. His success is scathingly disparaged in print by author Frances Trollope, one of the many Europeans who flocked to America and reported back with ironic and amused descriptions of American society. This famous exchange in Trollope's *Domestic Manners of the Americans* (1832) exemplifies the condescending tone of these travelogues yet exposes an inherent weakness in the concept of self-taught culture that was to have consequences by the turn of the twentieth century.

> *The great part of this day we had the good fortune to have a gentleman and his daughter for our fellow-travellers, who were extremely intelligent and agreeable; but I nearly got myself into a scrape by venturing to remark upon a phrase used by the gentleman, and which had met me at every corner from the time I first entered*

the country. We had been talking of pictures, and I had endeavoured to adhere to the rule I had laid down for myself, of saying very little, where I could say nothing agreeable. At length he named an American artist [Chester Harding], *with whose works I was very familiar, and after having declared him equal to Lawrence (judging by his portrait of West, now at New York), he added, "and what is more, madam, he is perfectly self-taught." I prudently took a few moments before I answered; for the equalling our immortal Lawrence* [Sir Thomas Lawrence, the English portrait painter and president of the Royal Academy, who was, ironically, self-taught] *to a most vile dauber stuck in my throat; I could not say Amen; so for some time I said nothing; but, at last, I remarked on the frequency with which I had heard this phrase of self-taught used, not as an apology, but as positive praise. "Well, madam, can there be a higher praise?" "Certainly not, if spoken of the individual merits of a person, without the means of instruction, but I do not understand it when applied as praise to his works." "Not understand it, madam? Is it not attributing genius to the author, and what is teaching compared to that?" I do not wish to repeat all my own bons mots in praise of study, and on the disadvantages of profound ignorance, but I would, willingly, if I could, give an idea of the mixed indignation and contempt expressed by our companion at the idea that study was necessary to the formation of taste, and to the development of genius. At last, however, he closed the discussion thus,—"There is no use in disputing a point that is already settled, madam; the best judges declare that Mr. H—g's portraits are equal to that of Lawrence." "Who is it who has passed this judgement, sir?" "The men of taste of America, madam." I then asked him, if he thought it was going to rain?*

The same year that Trollope made this observation, one author estimated that at least one hundred thousand young men in the United States were engaged in a course of self-education.[26] He ascribes weakness of character to those who have received formal education, and strength of character to those who have "measured their powers . . . in the school

of severe discipline." He attributes a gift for invention to self-taught men who must make do or innovate with the materials at hand, but he also cautions that the arts should not be spurned but recognized for the usefulness in "which self-taught genius, with the super-added effects of thorough instruction, can confer upon the millions of our country. . . . Genius lies buried on our mountains and in our vallies."[27]

Also in 1832, Americans were galvanized into a frenzy of self-improvement and soci-etal reforms through the optimistic pseudoscience known as phrenology. When Asa Ames carved his eerily beautiful sculptural portrait of a young girl with incised and colorful markings on her scalp, he was testifying to a runaway offshoot of Enlightenment faculty psychology that presented itself as a scientific method for self-improvement. Phrenology was conceived at the close of the eighteenth century in the medical circles of Vienna as a serious study of brain structure as it related to the complexities of the human mind. Dr. Franz Joseph Gall (1758–1828) divided the brain into twenty-seven organs that corre-sponded to faculties responsible for specific aspects of human behavior and proclivities. After Gall's death, his student Dr. Johann Spurzheim (1776–1832) expanded his mentor's theories and proposed that the formation of the skull itself conformed to these faculties.

Phrenology was introduced to American audiences through the first and only lec-ture tour given by Dr. Spurzheim, who died suddenly in Boston after contracting typhoid. The drama of this event and the public autopsy that followed ensured the early popular interest in phrenology. By mid-century, a vulgarized version known as "practical phrenol-ogy" had penetrated even the most rural areas, promulgated through the efforts of two brothers, Lorenzo and Orson Squire Fowler. Through the examination of the bumps on the head, a person's true nature could be analyzed and adjusted through an exercise of fac-ulties that were deficient and an atrophy of those that were undesirable: on this fast track to self-improvement, address the faculty and you could sculpt your own destiny. In 1859 educator Horace Mann made the explicit association between faculty psychology and the faculty stimulation of phrenology when he stated, "There are two grand laws respecting mind-growth. . . . The first is the law of symmetry. The faculties should be developed in

proportion. . . . The next law is as important as the first. It is that all our faculties grow in power and in skill by use, and that they dwarf in both by non-use."[28]

The Fowlers established a virtual industry operating from the phrenological cabinet they opened on lower Broadway in New York City. Their activities ranged from phrenological readings to the publication of journals and books on subjects promoting the benefits of health food, homeopathy, hydropathy, and mesmerism, and also agitating for women's and children's rights, sex education, and other reforms and therapies. The era of self-improvement was now the age of self-help.

Asa Ames carved the *Phrenological Head* around 1850, possibly for a homeopathic doctor he was living with shortly before his own death from tuberculosis. It is not known how he acquired his prodigious skills, but Ames's genius was to invent a genre of three-dimensional portraits in wood that had no real precedent in American folk sculpture. Like much painted portraiture of the day, the representations are direct, frontal, and iconic in their minimalist simplicity. The unusual flat—rather than pedestal-shaped—base of the bust- and waist-length carvings mysteriously derives from a beautiful but short-lived stone-carving tradition, perhaps innovated by Desiderio da Settignano in Renaissance Florence. How this obscure mid-nineteenth-century artist in the small upstate town of Evans, New York, became aware of this Renaissance device we may never know, but the twelve or so portraits of family, friends, and neighbors are imbued with the inspired soul of original genius.[29]

At mid-century, in the abolitionist novel *Uncle Tom's Cabin*, author Harriet Beecher Stowe describes the enslaved cook Dinah as a self-taught genius who, "like geniuses in general, was positive, opinionated, and erratic, to the last degree."[30] Independence from British tyranny had little impact on America's enslaved populations, whose lives continued much as they had before. The beautiful *Whig Rose and Swag Border Quilt* (Fig. 8) tells a much different story than the Hewson quilt. It was made in Kentucky, site of the opening pages of Stowe's novel. The quilt features minute and precise stitches of white thread on white cotton in various floral, tree of life, and basket designs that are interspersed with the

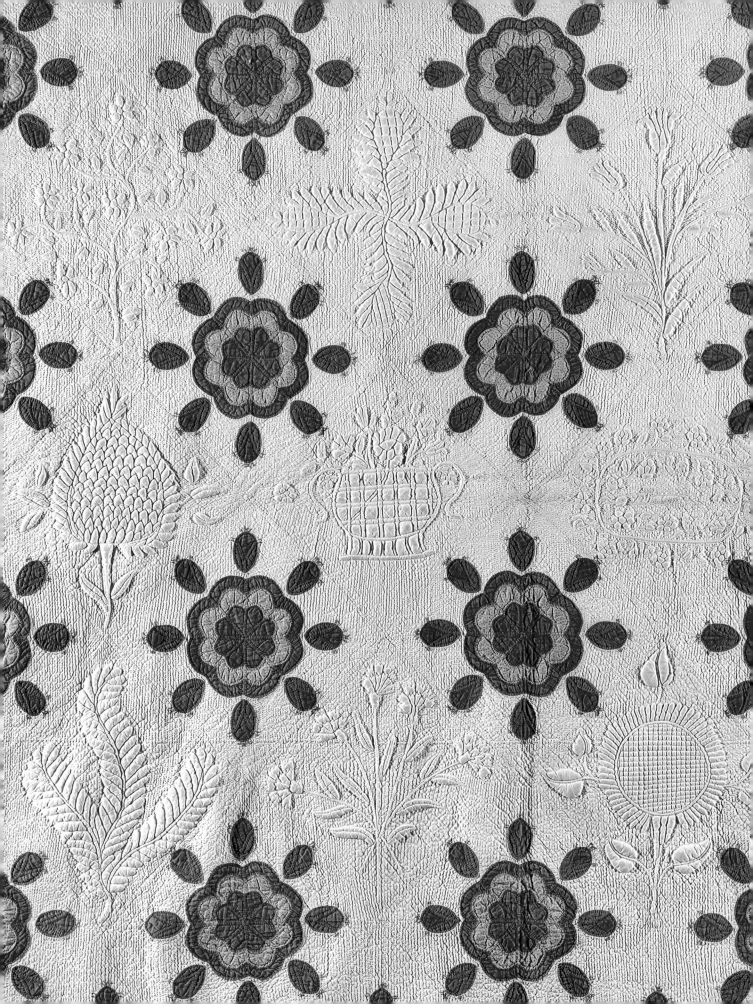

vibrant rose pattern in deep pink and green, enclosed within a federal swag border. It was made on the Russellville, Kentucky, plantation known as "The Knob," home of Mr. and Mrs. Marmaduke Beckwith Morton. Had it not survived with careful documentation, the quilt, no doubt, would have been ascribed to Mrs. Morton, as were most delicately made antebellum Southern quilts.[31] However, a handwritten label pinned to the back by a descendant in 1933 affirms that it was, in fact, made by female slaves of the household whose names and histories are slowly being recovered.[32] A quilt made as recently as 1983 by Jessie B. Telfair, an African American woman from Georgia, still cries "freedom" in a construction mimicking the stripes of the American flag, a response to racial prejudice she experienced at the beginning of the Civil Rights era.

Following the Civil War, the tenor of the self-taught idea began to change in response to growing industrialization, displacement of populations, and an altered social construct. Senator Henry Clay had coined the term "self-made" in 1832, when he testified before the Senate: "In Kentucky, almost every manufactory known to me, is in the hands of enterprising and self-made men, who have acquired whatever wealth they possess by patient and diligent labor." Although he intended "self-made" to describe someone who constructed self-identity through his own efforts, as he had, the meaning was changing into the more selfish yardstick of personal gain, an entirely different connotation that debased lofty Enlightenment values. On the one hand, it was perhaps more important than ever for the disenfranchised to see a brighter future for themselves and a fuller participation in American life; on the other, a divisive note of "have and have not" had been introduced. For a time self-taught culture progressed on two parallel tracks. In 1839 Horace Mann's *Common School Journal* rhetorically asked, "Why should that grim craftsman [the blacksmith] . . . have a mental cultivation beyond the ability to keep account of his horse-shoes and plough-irons, and read his Bible and newspaper? . . . If I send my son away from home to learn the trade of a builder, I do not

FIG. 8
Whig Rose and Swag Border
Quilt (detail)
UNIDENTIFIED SLAVES;
MADE FOR MRS. MARMADUKE
BECKWITH MORTON (1811–1880)
The Knob, Morton Plantation,
Russellville, Kentucky
c. 1850
Cotton
88 × 104"
Gift of Marijane Edwards Camp,
2012.8.1

want him to be a mere carpenter and nothing more. I want him to be a whole man, of enlarged mind and liberal sentiments."[33] African American artist Nelson A. Primus was still being called a self-taught genius in the *Cleveland Gazette* of 1890. But as public education became available to a wider swath of the American population, especially in urban areas, a greater divide of geography and opportunity developed; self-taught was increasingly associated with physical isolation from the mainstream and with marginal means rather than an optimistic national agenda. And as the national border pushed farther and farther west, self-taught, by the end of the nineteenth century, was as much a sign of iconoclasm and stubborn self-sufficiency as a unifying and moral philosophy.

Hosea Hayden stands at the nexus of self-taught genius and its turn toward singular, idiosyncratic creativity. Hayden descended from a family of farmers and shipbuilders who had fought in the Revolutionary War and migrated from Massachusetts to Ohio and Indiana in the early 1800s.[34] Perhaps his talent with woodworking was learned from some of these forebears, though most nineteenth-century men in rural circumstances did have experience working with their hands. Hayden starting making unusual chairs in 1883; the first is marked in memory of the one hundredth year of the "burth" of his father, Stephen. He made more than one dozen tripod folding chairs of his own construction and design, each distinctive, each a veritable journal of his beliefs and observations related through drawings and words scratched into every surface like an errant schoolboy. His method has been compared to scrimshaw (embellishments incised by whalemen into marine mammal skeletal matter), and certainly the etched lines colored with red and black ink evoke that art. He signs himself "H. H. Ingraver" in some examples. One family member in the 1930s remembers Hayden as "a versatile genius" and "a cherished neighbor and a loyal citizen."

Hosea Hayden may not yet have been an iconoclast, but he was certainly a maverick. His markings in wood express fringe, liberal, and mainstream beliefs, from calling John, author of the book of Revelation, a mentally imbalanced "crank" to supporting

women's rights. Hayden's chairmaking had its roots in the art of self-taught culture—which was often realized in a thoroughly individualistic manner—but it is also esoteric and singular in the sense that we now associate with the term "self-taught."

When Milwaukee self-taught artist Eugene Von Bruenchenhein (1910–1993) shouted his credo "create and be recognized" into the great I Am, he exhorted himself and others to find self-realization through the God-within, as Edward Young had two centuries before. The genius of the self-taught in America has been multifarious, echoing the fullness of the debates and theories postulated throughout the eighteenth century, from genius as simply a talent to its burning flame of original inspiration. Art history has been challenged by the role of these artists, whose lives have nonetheless left a remarkable trace. A definition of folk art has been elusive, in part, because the artists—past and present—have typically not concerned themselves with conventional art world expectations but have responded, instead, to the practical execution of a commission, the beautification of everyday life, and the fulfillment of self through a creative imperative. Recast as self-taught geniuses, the artists fit comfortably within a widespread self-taught culture that was mutable and responsive, changing naturally and organically as life in America changed. The self-taught artists of today represent a return to the genius who was never disciplined or broken by the rules of art, some of whom did not even know they were making *art* and only knew they needed to *make*. So we come full circle, back to Joseph Addison, the generous principles of self-taught, and the state of artistic purity that denotes original genius.

NOTES

1. Joseph Addison, *The Spectator* (London) 160 (September 3, 1711).

2. This is a paraphrasing of German philosopher Arthur Schopenhauer's (1788–1860) well-known maxim about genius, "Talent hits a target no one else can hit; Genius hits a target no one else can see," included in his writings on *The World as Will and Representation* (1819). It is through art that the eyes of the non-genius are able to see this deeper truth.

3. Thoughts about transitions in genius are concisely described by Johann Kaspar Lavater (1741–1801) in his influential work on physiognomy. For the purpose of this essay, I have relied upon Ken Frieden, "The Eighteenth-Century Introjection of Genius," in *Genius and Monologue* (Ithaca, NY: Cornell University Press, 1985), 66–83, available at Surface: Syracuse University Library, http://www.surface.syr.edu/books/12; and Bruce Duncan, *Lovers, Parricides and Highwaymen: Aspects of Sturm und Drang Drama* (Columbia, SC: Camden House, 1999), excerpts at Dartmouth, "German Studies," accessed December 2, 2013, http://www.dartmouth.edu/~german/German7/Genius.pdf.

4. The idea of "self-taught" was used as early as 1942 in the exhibition and catalog *They Taught Themselves: American Primitive Painters of the 20th Century* (New York: Dial Press, 1942). The term, however, came into common usage toward the close of the twentieth century.

5. Genius as a "familiar" is an idea that is not foreign to contemporary audiences; it still appears in works of literary fiction such as Philip Pullman's *The Golden Compass* (2003), in which "daemons" take physical form as an integral part of the psychological makeup of each character: severing the connection is tantamount to a lobotomy.

6. Anthony Ashley Cooper, third Earl of Shaftesbury, *Soliloquy, or Advice to an Author* (London: printed for John Morphew, 1710).

7. Edward Young, *Conjectures on Original Composition, 1759,* ed. Edith J. Morely (Manchester: Manchester University Press, 1918), 24.

8. Ibid., 14.

9. Walt Whitman, "Song of Myself," in *Leaves of Grass* (New York: Andrew Rome, 1855).

10. Thomas Jefferson, *Notes on the State of Virginia* [1781–1782; written in answer to "Queries proposed to the Author by a Foreigner of Distinction, then residing among us."] (Virginia: J. W. Randolph, 1853), 70–72.

11. Young, *Conjectures on Original Composition*, 13.

12. "Reuben Moulthrop 1763–1814," *Connecticut Historical Society Bulletin* 20, no. 2 (April 1955): 51.

13. Carolyn J. Weekley et al., *Joshua Johnson: Freeman and Early American Portrait Painter* (Baltimore: Maryland Historical Society in association with Abby Aldrich Rockefeller Folk Art Center, 1987), 55.

14. *The Monthly Anthology, and Boston Review Containing Sketches and Reports of Philosophy, Religion . . .* (June 1, 1806): 300.

15. John Michael Vlach, *Plain Painters: Making Sense of American Folk Art* (Washington, DC: Smithsonian Institution Press, 1988), 35. Vlach quotes Benjamin Franklin's sentiment that "All Boys have an early Inclination to this improvement [the arts], and begin to make Figures of Animals, Ships, Machines, & c. as soon as they can use a Pen; But for want of a little Instruction at that time, generally are discouraged, and quit the Pursuit." If this inclination were to be encouraged, America would produce a generation emboldened with "mechanical genius."

16. John R. Monsky, "From the Collection: Finding America in Its First Political Textile," *Winterthur Portfolio* 37, no. 4 (winter 2002): 252.

17. Florence Montgomery, *Printed Textiles: English and American Cottons and Linens, 1700–1850* (New York: Viking Press, 1970), 96.

18. Peter and Leslie Warwick, "The First American Painter of American Landscapes," *Antiques & Fine Art* (summer 2013): 129–36.

19. Although they were not always in agreement, Gerard and Duff built upon the ideas proposed by Young, who himself amplifies original ideas introduced earlier in the century by Joseph Addison.

20. Young, *Conjectures on Original Composition*, 7.

21. Alexander Gerard, *An Essay on Taste* (Edinburgh: A. Kincaid and J. Bell, 1759). In the language of his essay, Gerard, too, approached genius from a geographical point of view. His stance stated unequivocally that genius must be accompanied by taste: "For the perfection of its structure, however, genius requires the assistance of taste." Of the poets, he further wrote, "The vigour of their imaginations led them into unexplored tracks; and they had such light and discernment, as, without danger of error, directed their course in this untrodden wilderness."

22. Vlach, *Plain Painters*, 35.

23. Addison, *The Spectator*.

24. Eleanor H. Guftason, "Collectors Notes," *Antiques* (October 1990): 662, 698. Early in his career Phillips placed advertisements in Berkshires newspapers, in 1809 and 1810, the only two that have come to light. In addition to his guarantee, the young artist promised likenesses in a "correct style, perfect shadows, and elegant dresses in the prevailing fashion of the day."

25. Stacy C. Hollander and Howard P. Fertig, *Revisiting Ammi Phillips: Fifty Years of American Portraiture* (New York: Museum of American Folk Art, 1994), 49.

26. B. B. Edwards, *Biography of Self-Taught Men* (Boston: Perkins & Marvin, 1832), xiv.

27. Ibid., xlix.

28. Excerpt from an address delivered to the graduating class of Antioch College in 1859, quoted in Daniel Walker Howe, *Making the American Self: Jonathan Edwards to Abraham Lincoln* (Cambridge, MA: Harvard University Press, 1997), 127.

29. German philosopher Immanuel Kant (1724–1804) interjects the notion that without genius to provide the "soul" or "spirit," art might be deemed successful in conventional terms but is ultimately uninteresting and uninspired. See "Immanuel Kant: Aesthetics," Internet Encyclopedia of Philosophy, http://www.iep.utm.edu/kantaest/.

30. Harriet Beecher Stowe, *Uncle Tom's Cabin* (Boston: John P. Jewett, 1852), 226.

31. Cuesta Benberry, *Always There: The African-American Presence in American Quilts* (Louisville: Kentucky Quilt Project in association with Museum of History and Science, 1992). In this groundbreaking book, Benberry explodes the idea that all quilts made by African Americans subscribed to a specific set of attributes that were carryovers from African textile traditions. Rather, she proves that African American quiltmaking in America is as diverse in expression and skill as quilts made in other groups in America.

32. A second quilt with closely related quilting motifs was also made at "The Knob" and is now in the collection of the Metropolitan Museum of Art, in New York. According to the Metropolitan's curatorial notes, the quilt was made by two sisters, Ellen Morton Littlejohn (1826–1899) and Margaret Morton Bibb (c. 1832–c. 1900/1910), who were slaves in the Morton household. The two women remained with the family after emancipation and died at the plantation. Lauren Arnold, deputy registrar and rights and reproductions coordinator, American Folk Art Museum, is trying to establish whether these same women made the quilt that recently entered the American Folk Art Museum's collection with a similar history.

33. Howe, *Making the American Self*, 126.

34. Angie Mills, "Hosea Hayden: Homilies to Sit Upon," *Folk Art* 19, no. 3 (fall 1994): 44–47.

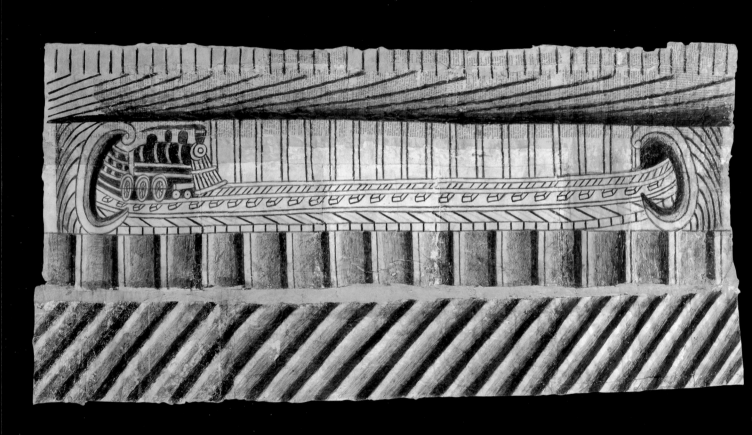

THE OBLIQUE ANGLE
When the Self-Taught Artist Shapes the World

Valérie Rousseau, PhD

> *Be wary of rare commodities! They do not exist, they are myths…. The genius…, the gift of creation, it is as common as carbon and hydrogen, and no human being lacks it.*
>
> —Jean Dubuffet[1]

The inventor of "art brut," French artist and collector Jean Dubuffet, questioned the notion of the artist as exceptional through the figure of the "common man," challenging the assumption that art is a domain reserved only for those trained in art schools. Beyond pure provocation, Dubuffet's belief stands as a criticism of the institution in all its forms, and of cultural ideologies governing Western societies. By amassing a substantial collection of artworks created outside the traditional frames of references, linearity, and weighty heritage of canonical art history, Dubuffet established a founding moment for the recognition of these self-taught artists.

The attention shown by "professional artists" toward these off-discipline creators is historical.[2] The German artist Kurt Schwitters wrote that "Art doesn't depend on the professional artist, as such a profession doesn't exist in itself. So it happens that art is in the realm of the professionally incompetent, where one least suspects it. Art is precisely a singular flower which does not tolerate soil of any kind. And this impulse shall not be annihilated, for this race of refined, sensitive and degenerate men will never disappear."[3] In other words, artistic professionalization does not "make" the artist, but autodidacts are not systematically better artists either. Many mainstream artists are, to some extent, self-taught, and many self-taught artists are professionally accomplished in other fields of expertise.

Thus, the self-taught paradigm is intrinsically diverse in terms of modes of expression, cultural references, social affiliations, forms, and aesthetics. Propelled by an urge and intensity in their process, these artists seem to operate on the precipice of discovery and actualization. Though largely self-referential and fueled by firsthand experiences, their

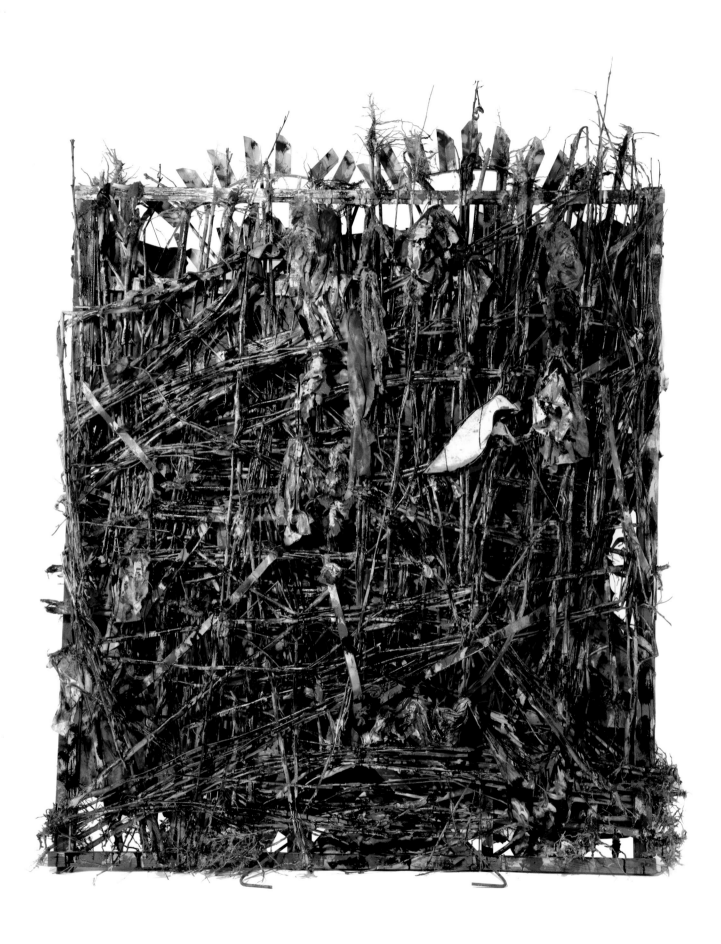

artworks embrace collective and universal concerns, connecting the seemingly uncon-
nected in significant ways. Their "genius" lies in their inventiveness and ambition, as
well as in the timeless capacity of their art to "shake off the dust." The unsettling and
illuminating viewing experience recalls less other artworks but more, as psychoanalyst
Béatrice Steiner stated, "a mode of visual construction that reproduces the mechanism at
work in a dream."[4]

EXCEPTION AND OTHERNESS

> *Does art history have to recognize such ramblings, which owe nothing to the imi-*
> *tation of the works of others . . . and are obscure only in proportion to the light*
> *with which our culture honors its own productions? Can it even, this history, report*
> *them without being itself disputed in its true principle, like a cultural institution*
> *sealed as an ideology which could not admit that art creation can be the business of*
> *everyone, . . . while our society strives on the opposite to distribute it to whomever*
> *it may concern, as a supposed gift?*
>
> —HUBERT DAMISCH[5]

The philosopher Hubert Damisch deduced the problematic nature of the works created
outside the official art system. He asserted that the accessibility of the common man to
artist status weakens art history, its epistemological structure and its instances of legit-
imization (peers, art critics, markets, collectors, museums).[6] Indeed, Thornton Dial,
Sister Gertrude Morgan, and Martín Ramírez (Fig. 1) confound this narrative. How does
one proceed to an incorporation within the actual art world discourse without excessive
patronization or a constant emphasis on incongruity? Sociologist Pierre Bourdieu argued
that it requires a discoverer, "one invested with the history of this field," to pronounce it
art.[7] Differently, Dubuffet claimed that these creations express themselves straightaway

as art—the activity of these creators is artmaking, therefore having implications for the concept itself: "Art Brut is Art Brut and everybody very well understood," he shouted out, using a tautological form.[8] With an anti-primitivist attitude, he wanted to ruin the underlying presumption of an operation of artistic legitimization by dispossessing those authorized to legislate in this field. To proclaim it "art" is to give these creations a greater agency.

This inclusion implies a heartrending revision of the concept of art itself—a revision, wrote philosopher and aesthetician Mikel Dufrenne, that reminds us that "The popular practice of art is at the origin of art: As long as artists were not recognized as such, and liberal arts distinguished from mechanical arts to later be called fine arts, and again considered 'high' by being set apart from 'low,' craftsmen and working-class people were the ones who produced 'art.' The entire community played, danced, sang. And this popular practice did not stop continuing in the margins and behind the scenes."[9] During the last forty years the art establishment, its authority disputed, has been pressed to open the discourse to practices neglected in the specialized studies in art history. A post-colonialist era unveiled objects, peoples, and histories that had until then remained invisible.

In an article discussing the cultural status quo, art critic Thomas McEvilley reacted to the persistent difficulty of the contemporary art world's unwillingness to embrace cultural differences. Referring to the productions of Thornton Dial (Fig. 2), Lonnie Holley, and Ronald Lockett, which exhibit deeply coded narrative content, he explained that the works and practices of African Americans reflect on black American vernacular traditions that are not yet integrated into our general art understanding. They offer a re-examination of the fundamental tenets of Western democracy and race relations.[10] For instance, how do we interpret the visual axis of Bill Traylor's "constructions," around which animals and figures chase one another when not falling into empty space?[11] Is this structure the public fountain from the everyday landscape of the artist, or does it conjure up, all at once, the darkness of crucifixion (crosses), the brutality of lynchings (gallows), and the miseries of slavery (cotton presses)? Alterity, or the recognition of otherness, is in question here. The

opacity that tends to cloud our access to the works of self-taught artists comes from our shared inability to close the distance that separates them from us, by sticking on interpretations borrowed from the dominant artistic tradition—an exogenous approach that has been historically contested. Add to the mix the position of the creators themselves, harvested in mindsets in which codes of access are deliberately veiled. Let us think of Henry Darger's multilevel oeuvre, its density complicating the intellectual process, or the example of James Castle, who never titled, dated, or commented on his works, frustrating our attempts to establish a chronology and a comprehensive evolution.[12]

The deficit of information on artists working outside established artistic channels remains the Achilles' heel of their recognition. We must search, record, and identify the distinctiveness of the work and its social, cultural, and historic counterweight, even more so if the artist is not actively involved in the elucidation of his or her process. Dubuffet tried to establish elements of knowledge in each work he collected, its *terroir d'origine* (native roots), borrowing obliquely from the approach of the ethnologist without neglecting the individualistic contribution of each artist. The published results of his investigations suggest that he focused particular attention on primary sources, as well as the way these creators interact with their environments.

The artworks usually present themselves as unfinished monologues, establishing consequently a superficial and caricatural terminology (with qualifiers like "mysterious," "enigmatic," "funny," "naive"), far away from the reality of the work and the artist. The discourse is built backwards, through the eye of the discoverer and the agenda of the interpreter.[13] Regarding this context of appropriation, we should not be surprised if the history of art brut and folk art is one of a perpetual idealization, which in the long term negatively impacts the acceptance and preservation of a whole field of creation.

For self-taught artists, favorable circumstances need to align in order for their works to be discovered, preserved, and then collected.[14] They are not found in the usual playground of the mainstream art world. History shows us that this kind of "rescue" is the result of a highly biased intervention, a pilgrimage led by a favorable family member or

passionate acquaintance. Before its conservation by the American Folk Art Museum, the *Palazzo Enciclopedico* (Fig. 3) by Marino Auriti remained in storage for twenty-two years, during which time his family failed to gain the interest of well-established art museums and architectural organizations, all of which declined to get "such a piece" in their collections.[15] Therefore, the current vitality of this kind of material is less dependent on the politics of acquisition by star museums than on the wills of isolated individuals. More often than not, these works are destroyed or vandalized. Only a small percentage has survived.

Ingenuity: An Oblique Angle of Vision

> *Marino Auriti is a retired auto body shop owner with the talent of a cabinet maker, the dreams of an architect and the soul of a philosopher.*
>
> —Henry O. Darling, *Philadelphia Bulletin*, c. 1958

FIG. 3
The artist with Encyclopedic Palace/*Palazzo Enciclopedico/ Palacio Enciclopedico/Palais Encyclopédique* or *Monumento Nazionale. Progetto Enciclopedico Palazzo* (U.S. patent no. 179,277)
Marino Auriti (1891–1980)
Kennett Square, Pennsylvania
c. 1950s
Wood, plastic, glass, metal, hair combs, and model kit parts
11 × 7 × 7'
Gift of Colette Auriti Firmani in memory of Marino Auriti, 2002.35.1

The "genius" of self-taught artists is often at least partially a result of their oblique angles of vision, which may highlight and invoke subjects, experiences, fears, and desires that are not typically externalized or deemed worthy of note. Somehow intuitive in their approach, they tend to apply standards and idiosyncratic levels of expertise to fulfill their personal needs. In *La pensée sauvage* (The Savage Mind), the anthropologist Claude Lévi-Strauss contrasted the concept of bricolage, a construction that results from tinkering with materials that happen to be available, to the methods of the engineer, which rely on the systematic use of a set of basic tools belonging to a specific science.[16] The process attributed to autodidacts is consequently remanded to an intermediate zone between disciplines. Operating outside preestablished rules and feeling unpressured to abide by them, they may be perceived as overtly resistant to conditioning.

For self-taught artists, the creative impulse often arises at a turning point in their lives, at a moment when they need to reinvent themselves: separation, disease, loss of a loved one, an impending move, emigration, radical isolation, retirement.[17] These are some of the many psychological circumstances that lead to perceiving the world in a sharper and more sensitive way.

When art comes from outside the expected frames of the art profession, it tends to follow original, creative, and unsuspected paths. After a long illness precipitated his retirement in 1937, Morris Hirshfield began to paint, applying to his art techniques from the garment and slipper manufacturing in which he had been professionally involved during his life. He made preparatory large-scale drawings—as if they were patterns for clothing to be assembled after cutting—sketching outlines of the major forms before he began to paint. His knowledge of textiles is visible in his paintings through a decorative repertoire of ornate fabric, striped upholstery, and embroidered clothing. James Castle, for his part, never adopted conventional means of communication due to congenital deafness. Firsthand accounts described his focus and inventiveness when it came to conceiving his own artistic tools and techniques: refusing to use typical art materials when offered, he drew with soot from the family stove, dampening it with his saliva, on discarded envelopes and other paper goods from his parents' home post office and general store. The condensed and fluid ballpoint pen drawings of Consuelo (Chelo) González Amézcua, which she called *filigranas*, evoke Mexican filigree jewelry and its arabesque patterns. This style also recalls the technique of *paperolles* (quilling)—crowning achievements of patience created by nuns in monastic communities, and used in modest churches to imitate the decorative work of gold- and silversmiths. Eugene Von Bruenchenhein, who dropped out of high school, "became fascinated with botany and science, and wrote extensively on his own metaphysical theories of biological and cosmological origins, as well as the primal genesis of a genetically encoded collective knowledge. He also composed reams of poetry on nature, love, war and politics, and imaginary travels through time and space."[18]

Art as an Intricate System

With Art Brut, it seems we have to deal with something very archaic, that should maybe be compared to medieval creations, where the idea was not at all to instill a feeling of beauty, but devotion, an adherence to myths, to beliefs.

—Michel Thévoz[19]

When Italian-Canadian Palmerino Sorgente (Fig. 4)—publicly known as the "Pope of Montreal"—was asked if he was an artist, he gave an illuminating reply: "I'm a Creator, an inventor. I can do everything."[20] According to his conception, an artist is a multifaceted person, somehow omniscient like God, able to do and perceive things that others cannot. Once, William Hawkins declared: "I was born an artist. I have been doing everything which you have to go to school for. I can do, beat you doin' it."[21] Eugene Von Bruenchenhein identified himself primarily as a multidisciplinary creator, working from poetry and philosophy to painting, drawing, photography, and sculpture, using every way possible to serve his intensive creative energies.

When these artists appropriate and use the term "art," it has a wider implication than our most recent conception of art, surpassing mere reference to artistic paradigms and conventions. Art is instrumental to a mission or goal pursued, responding to some sort of daily utilitarian functions. In this context, each artwork seems to be a component, a gear, in the whole system of the artist, like a lifelong continuous *Gesamtkunstwerk* (total work of art), reminiscent of a Renaissance moment, when fields of knowledge were not fragmented. Organically unified, the individual pieces embrace a consecutive and complementary role in the ultimate project. These expansive and intricate creations, "muddled as the circuits of the memory, seem to follow the moving functioning of a thought looking for itself," as suggested by writer Jean-Louis Lanoux.[22] Their overly controlled development and general coherence reflect this principle, as well as their integration with all other

aspects of their lives. The act of creation takes over the rest, in a steady and monastic way. "I am intoxicated," said painter Ralph Fasanella.[23] The creative act becomes inseparable from the individual, as a religion for its minister or a homeland for its president. "When I'll die, my painting will die with me," declared Hawkins.[24]

This fusion is most apparent with "art environments," which involve an architectural or landscape component. These self-referential sites, private in content, intervene nevertheless in the public sphere, as if their creators were speaking out loud.[25] For instance, Jesse Howard filled up his land with hand-lettered painted panels. Signs of protest and free speech relevant to his own life experiences and personal torments, they stand as accusations to his vandals, commentaries on politicians, and lessons from various biblical verses. Other examples are "yard shows" created by African American artists in the South, which began to be noticed by the outside world during the late 1960s through the 1970s. This cultural phenomenon existed for centuries but was previously expressed in secrecy behind and inside residences. Among the practitioners are Sam Doyle, Lonnie Holley, and Purvis Young, but also Mary T. Smith, who designed a place of her own in order to circumvent the stigma of a hearing impairment that often left her feeling socially misunderstood: "I don't go nowhere no more. I can't hear nothing. I don't need nothing. I got it all here. My church. The Lord Jesus." As collector and writer William S. Arnett recounted, "She also could dress her message. An interesting relationship existed between Smith's wardrobe and her art. In her closet, Smith kept an extensive dress collection defined, as was her yard, by juxtapositions of the spiritual and the mundane."[26] Doyle also marked his living space: in his outdoor museum-like display, he curated a "lesson" gallery of portraits, paying tribute to the history of his Gullah community in South Carolina and African American lore. A devout Baptist, his saints intermingle with public celebrities and local luminaries like Mr. Fool, Food Stamp, Ramblin' Rose, and Rockin' Mary.

Many assemblages by Thornton Dial, like *Birds Got to Have Somewhere to Roost* (2012), pay tribute to the tradition of yard shows, depicting these visual components and landscapes. Along with highly poetic and evocative titles—*Bone Dry* (2011), *Freedom*

FIG. 4
Palmerino Sorgente (1921–2005) in his workshop on Notre-Dame Street, Montreal, Canada

53

Cloth (2005), *History Refused to Die* (2004) (Fig. 2), *The Art of Alabama* (2004), *Equal Opportunity: Mosquitoes Don't Discriminate* (2002), *Cotton-Field Sky Still Over Our Head* (2001)—these works depict the deeply embedded brutality endured by African Americans during their quest for justice, as well as the overall power of their oral culture.

The Messenger and the Message

During the Renaissance, the status of genius was attributed to a "person who, momentarily inspired by God, could perform a great task," an idea that coincides with Sorgente's position.[27] From the end of the fourteenth century, the etymology of the term was associated with a "tutelary god, a guardian deity or spirit," an individual capable of channeling external or divine influence and watching over people.[28]

The connection with the supernatural and the afterlife is remarkably common ground for many self-taught artists. It explains their artistic impulse but also provides a context for being uprooted and redefined under new foundations. Art historian Michel Thévoz suggested in an article referring to mediumistic artists (historically related to art brut), that this "relation" was a social alibi for the common man who is afraid to proclaim himself a painter.[29] The attribution of a mission bestowed by uncontrollable powers could serve as a way to evade condemnation by relatives. They can more easily reconcile with the fate of creation than the irrepressible drive coming from inside.

William Edmondson, who lost his hospital job at the onset of the Great Depression, claimed to have experienced a heavenly vision in the early 1930s, citing a disembodied voice instructing him to gather his tools and begin to work on a tombstone. As he poetically testified: "I looked up in the sky and right there in the noon daylight, He hung a tombstone out for me to make."[30] A devout member of the United Primitive Baptist Church, Edmondson promptly complied with this divine directive, and soon the yard behind his house began to fill up with limestone tombstones and sculptures. He regularly

FIG. 5
Untitled
Eugene Von
Bruenchenhein (1910–1983)
Milwaukee, Wisconsin
c. 1940s–mid-1950s
Gelatin silver print
10 × 8"
Gift of Lewis and Jean
Greenblatt, 2000.1.4

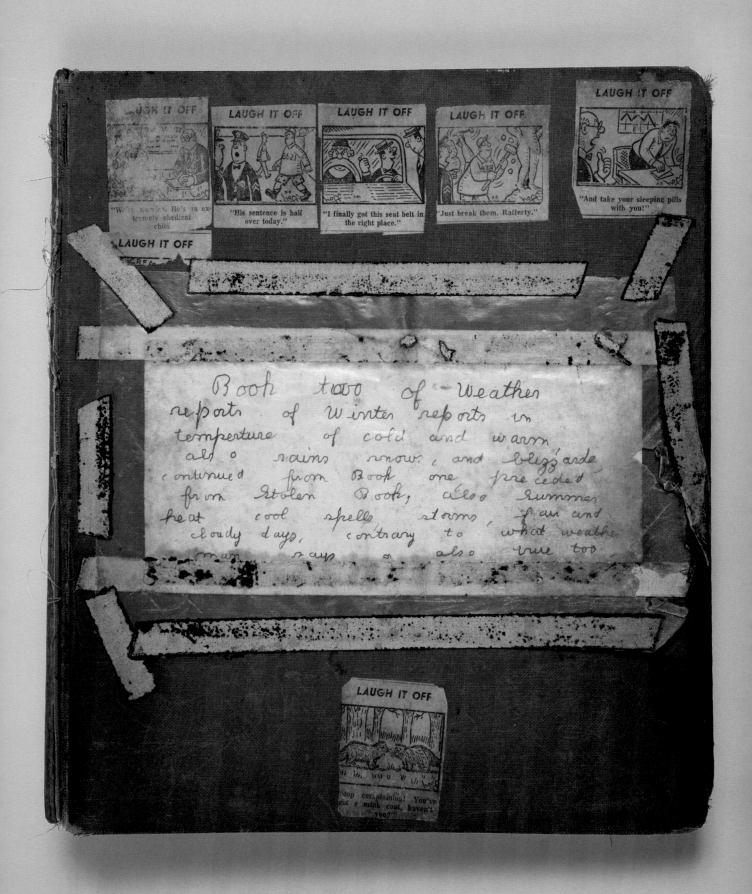

Book two of Weather
reports of Winter reports in
temperature of cold and warm
also rains snows, and blizzards
continued from Book one preceded
from Stolen Book, also summer
heat cool spells storms, fair and
cloudy days, contrary to what weather
man says also true too

referred to his works as "miracles." Similarly, Felipe Benito Archuleta reported a vision in 1964 instructing him to make woodcarvings. (Like Edmondson, he was at the time unemployed.) He is known for his ferocious life-size animals, created with a chain saw and detailed with a pocketknife. Sister Gertrude Morgan's primary purpose for painting could be considered divine intervention, not a complete subsumption by the self, although the self certainly became the medium for the divine message. This dialogue or mission is not systematically religious for other artists, following the example of Von Bruenchenhein (Fig. 5), who admitted that his art resulted from "unknown forces at work . . . forces that have gone on since the beginning."[31] Ironically, Von Bruenchenhein referred to his own creative ego as his "genii": seemingly a compound word of his own first name and "genius." According to him, the genii acted as a muse, apparently sitting on his shoulder and talking to him. When it stopped talking, the artist would no longer be able to work.

The relationship to aerial spheres is manifested in the eloquent iconography found in self-taught art, as exemplified by the number of works where figures are shown rising and ascending. We can find a considerable directory of divinities and celestial figures, among them, pedestaled and idealized women at once goddess, star, queen, femme fatale, and Madonna (González Amézcua, Hirshfield, Ramírez, and Von Bruenchenhein, to name a few), skies (think of the dramatic skies in Darger's watercolors, which tell of his obsession with weather conditions) (Fig. 6), and flying vessels (for instance, the flying machines of Charles A. A. Dellschau, meant to chronicle the exploits of the Sonora Aero Club, active in California in the 1850s). Even more prototypical of the artist's desire to reach a higher level are visionary architectures and constructions, from the megalopolises of Marcel Storr (Fig. 7) to the *Watts Towers* of Simon Rodia (which he called *Nuestro Pueblo*, meaning "our town"), a 4,300-square-foot Los Angeles art environment of seventeen structures, two of which rise to a height of nearly one hundred feet. The meticulously executed and elaborate architectural renderings by Achilles G. Rizzoli, dating from 1935 to 1944, symbolized for their part the metamorphosis of a friend or a family member and architectural personifications of their attributes. Among these transfigurations in buildings

are five birthday tributes (the *Kathredals*) to his mother, whom he venerated for her strength, beauty, and spiritualism. There are also the ethereal architectural motifs of Von Bruenchenhein (notably his 1970s skyscraper-fortress paintings, his precarious *Gold Tower* made of chicken bones and model airplane glue, and his early *Pile of Andrius*, showing a metropolis perched atop a hill). Marino Auriti was ambitious with his *Palazzo Enciclo-pedico* (Fig. 3), a model (eleven feet tall by seven feet in diameter) meant to be built on a scale of 1:200. The unrealized construction would have stood 136 stories and 2,322 feet, and spread across sixteen city blocks in Washington, DC, just slightly smaller than the Burj Khalifa skyscraper in Dubai, completed in 2009—the tallest man-made structure in the world, at 2,716½ feet. As Auriti wrote in his highly technical six-page statement of purpose, "This building is an entirely new concept in museums designed to hold all the works of man in whatever field, discoveries made and those which may follow, . . . everything from the wheel to the satellite."[32]

ENCODING AND CAMOUFLAGE

Art Brut is inopportune. . . . The creator takes the initiative of the misunderstand-ing. The viewer is totally spurned. Their systems not only are not communicable, but they draw sustenance from and reactivate themselves on this incommunicability.

—MICHEL THÉVOZ[33]

While works by self-taught artists are often fictional narratives or pleas, autobiographies, or dialogues with spirits, for the most part they reflect a certain dysfunctional communi-cative component. From the makers to the viewers, meaning is easily lost in translation. Is the blurring of clues to enter the work a strategy for the artists to keep others away, at a certain distance, a form of camouflage that allows them to keep complete control

FIG. 7
Untitled (Megalopolis)
MARCEL STORR (1911–1976)
Paris
1969
Ink, colored pencil, and varnish on Canson paper
20 × 24"
Collection of Liliane and Bertrand Kempf

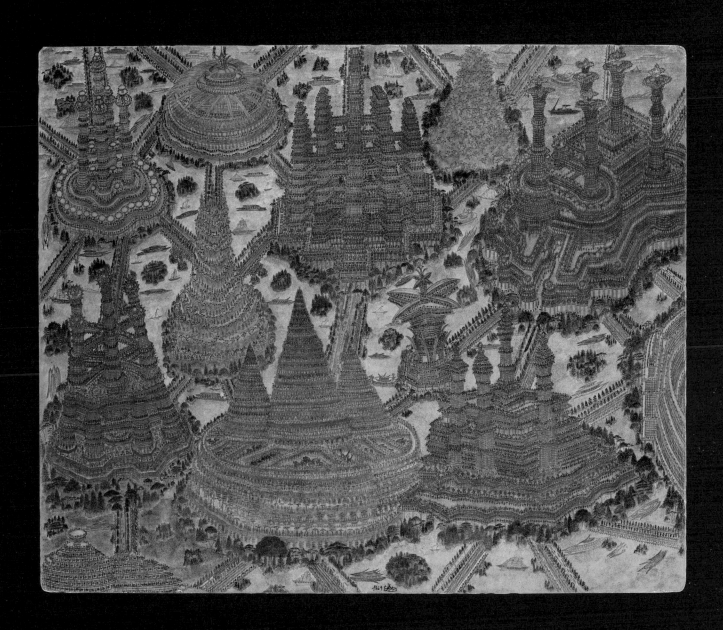

over their project? How freed can an individual feel by creating seemingly unintelligible artworks? Are they creating a necessary diversion of language, made of self-reflexive mechanisms and elliptical conundrums, which allows them to follow a quest or reach a greater personal well-being, as a kind of panacea?

Among these "encoders" is John Bunion (J. B.) Murray, who could neither read nor write. His paintings, composed of superimposed layers of letters, signs, figures, and lines, appear like the deformed and unstable mirror of a stretch of water. As reported by artist and author Judith McWillie, "believing he had experienced a vision from God, he began writing a non-semantic script on adding machine tape, wallboard, and stationery. He described it as 'the language of the Holy Spirit, direct from God' and prayed over it using a bottle of water as a focusing device—staring at the water and asking if he was doing the will of God."[34]

James Castle's illiteracy and deafness are somehow aesthetically perceptible in the evanescent, smooth, and subtle surfaces of his compositions, leaving an apparent silence. Developing his own unique sign system and visual vocabulary, he was thus able, especially in his handmade books, to expose the gap between sign and signified—we are shown scraps of words, rearranged letters, scribbles imitating text, linguistic clues. Therefore, he seems to express that a "meaningful" language is the product of conventions.

A similar mechanism is perceptible in Judith Scott's art: her sculptures indicate a calculation between being and appearance, between the simultaneous desire to reveal and to hide stolen objects under lengths of knotted wool and acrylic yarns.

Something indecipherable pervades the postcard-sized elaborate schematics of Melvin Way. Despite a formal consistency in his drawings, which show superimposed algebraic equations, chemical formulas, diagrams, and cryptic imagery, the codes used defy our comprehension because of its randomness. This opacity is symbolically reinforced with tape, which partially seals the surfaces of his drawings.

The artworks of the high-functioning calendar savant George Widener (Fig. 8) —vessels (like the *Titanic*), symmetrical cities, and square grids—are covered with

inventories and patterned with dates. "I plan them with calendar dates, then it helps them improve."[35] They balance and structure his search "to make order out of the chaos" and somehow anticipate catastrophes. He argues that in a "very dramatic technological future," intelligent machines will be able to "read the subtleties of [his] artworks," and then fully achieve his ambitions for a more "holistic kind of environment."

These universes, sorts of private theaters, seem to operate in closed circuits (for internal use only). Professor of American material culture Bernard L. Herman recalls that Bill Traylor "made art in public view and that he apparently talked, at least intermittently, as he worked. Arguably, he may have been talking to himself or to observers like artist and collector Charles Shannon, who collected and championed Traylor's art. But, we might also consider the possibility that Traylor was speaking to the pictures as they took form. . . . Holley, making art, speaks to the work as it takes shape in his hands, explaining, singing, musing. Holley's is a practice that pours words into images and sculptures as if they were vessels to be filled, emptied, and refilled in each telling."[36]

These creators invent a vocabulary and theories of their own, disguising the letter and the shape. Out of this configuration emerges a second identity, a resurrection, an imaginary family tree, attempting to impose a new order and change the course of fate. In these creations, the fictional self exists in a kind of hyperreality.

An Alternative Canon

In the United States, both folk art and contemporary self-taught art have been important cultural symbols since the time they first began to appear in the American art world before World War II up until today, seen as an alternative to academically trained art, and as closer to American values like democracy and rugged individualism. One might suggest that the mainstream culture has been continually rewritten by the people at its margins. From the "common man" to the "outsider," "ordinary" people lead their lives

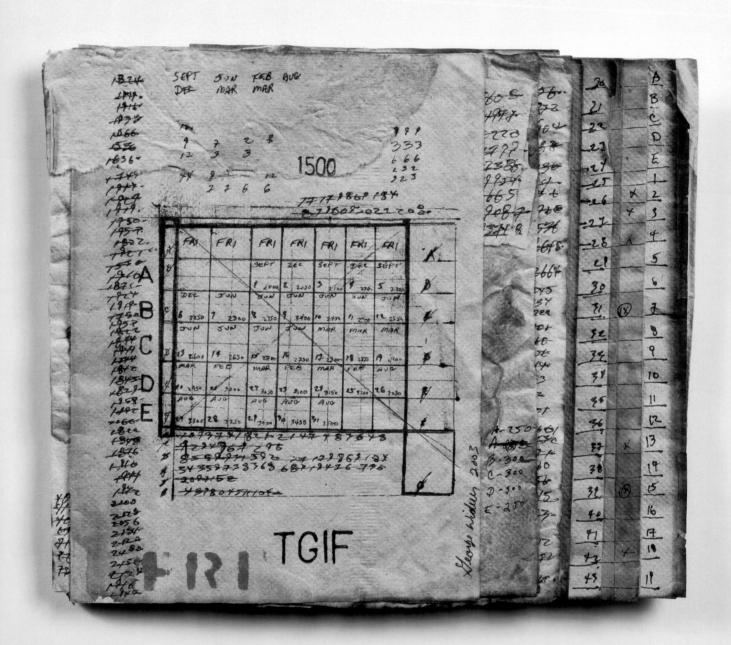

indistinctly for years, until one day, unexpectedly, they begin to question the views of the broader public. Active participants in their own unfulfillment, they seek to control their own destinies in a world that insists that they can't. As noted by writer and critic Alissa Quart, "What is surprising is that artistic, cultural and scientific institutions seem to need them, or are being inspired—or reinvigorated—by them."[37] They are not perceived as threats to American cultural values but rather as guardians of these basic national values. Consequently, these individuals, who challenge our understanding of what is "normal," manage to establish lively artistic traditions (like Felipe Benito Archuleta, Henry Darger, and Thornton Dial, to name a few) and influence younger artists.

In their absolute diversity, these oeuvres imply a reflection on current value systems that correlate with social structures. This art blurs frontiers between disciplines, makes definitions look constricted, and forces us to reconsider our assumptions about authoritative systems. We are offered a view of the familiar in terms and forms that may expose underlying prejudices and assumptions.

Artistic inspiration emerges from unsuspected paths and unconventional places, framing the world differently than we ordinarily do. The "genius" of the "self-taught" is the voice articulated by the unexpected as a transformational tenet for a society, proving the power of individuals situated outside the social consensus to define our visual culture.

FIG. 8
TGIF Booklet
GEORGE WIDENER (B. 1962)
Ohio
2003
Ink on burnt and dyed found
paper
6½ × 8 × ½"
Gift of Jacqueline Loewe
Fowler and Barbara Blank
Shapiro, 2008.10.2

NOTES

1. Jean Dubuffet, reply to the questionnaire "Pourquoi ne croyez-vous pas en Dieu?" (Why don't you believe in God?), *Le Peignoir de Bain* IV (1954): n.p.

2. Among them are the artists related to romanticism and realism. On the one hand, the idealization of self-taught artists can be understood as the victory of transgression over oppressive cultural standards: by shaping and practicing their creative impulse outside of conventional artistic circles, their works are enabling a "more accurate" representation/expression of the "real self," unimpeded by the cake of social custom, fashion, and influence. On the other hand, for these professional artists, such inspirational, exotic visual statements seem to carry repressed and neglected values of the occidental culture they found essential to exalt. The artworks bring a feeling of déjà vu, where the distant appears suddenly close and recognizable. Michel Thévoz, *L'Art Brut* (Geneva: Skira, 1981), 76.

3. Kurt Schwitters, "Art et temps" (1926), in *Merz* (Paris: Éditions Gérard Lebovici, 1990).

4. Béatrice Steiner, comment on "Louis Soutter fait son Marché," *Animula Vagula: Rives et Dérives de l'Art Brut* (blog), February 17, 2010, http://animulavagula.hautetfort.com/archive/2010/02/index.html.

5. Hubert Damisch, "Art Brut," *Encyclopædia Universalis* (Chicago, IL: Britannica, 2002), CD-ROM.

6. There are no such things as "communities" of self-taught artists, from which emerge a whole system of recognition, exclusion (selection and election), and sociability (alliances, exchanges) with peers. This creator acts as a free electron.

7. Pierre Bourdieu, *The Rules of Art: Genesis and Structure of the Literary Field*, trans. Susan Emanuel (Stanford, CA: Stanford University Press, 1996), 246.

8. Jean Dubuffet, "L'Art Brut" (1947), in *Prospectus et tous écrits suivants*, vol. I (Paris: Gallimard, 1967), 176.

9. Mikel Dufrenne, "Populaire," in *Vocabulaire d'esthétique*, ed. Étienne Souriau (Paris: PUF/Quadrige, 2004), 1159.

10. Thomas McEvilley, "Afterword," in *Thornton Dial in the 21st Century*, eds. Paul Arnett, Joanne Cubbs, and Eugene Metcalf Jr. (Atlanta, GA: Tinwood Books in association with the Museum of Fine Arts, Houston, 2005), 312–16.

11. In an undated handwritten note, artist and collector Charles Shannon specifies that there are "about twenty-five similar works done late in the three year period of his artistic productivity." Archives American Folk Art Museum, New York.

12. By their scope and ambition, Henry Darger's 15,000-page *The Story of the Vivian Girls, in What Is Known as the Realms of the Unreal, of the Glandeco-Angelinian War Storm, Caused by the Child Slave Rebellion* and 5,000-page autobiography, two manuscripts with fastidious descriptions and a complex gallery of characters and historical facts, require an avid and relentless reader. Passing through the whole oeuvre allows one to identify a unique space, style, and personal language, made of rhythms, keys, and patterns. Michael Bonesteel, who has published extensive research on Darger, has attempted to date the volumes that make up *The Realms of the Unreal*. The texts for the first seven volumes bear dates spanning 1910 to 1913: Volume I covers 1910 to 1912; Volume II, 1910 to 1912; Volume III, 1912 to 1913; Volume IV, 1912 to 1913; Volume V, 1913; Volume VI, 1913; Volume VII, 1913. This does not mean that Darger wrote them in those years, however, as he seems to have rearranged the pages constantly, but as they were bound in 1932, they would have to have been written by that year. In the following volumes, all unbound, the texts bear dates spanning 1913 to 1917: Volume VIII has no date; Volume C (both Bonesteel and John MacGregor, another expert on Darger, agree that it is Volume IX), 1913; Volume X, parts 1 and 2, 1913; Volume XI has no date; Volume A (Bonesteel labeled it Volume XII), 1914 to 1917; Volume VII (Bonesteel labeled it Volume XIII, MacGregor Volume XII), 1915; Volume B (Bonesteel labeled it Volume XIV, MacGregor Volume XIII), 1915 to 1917. How long Darger spent writing *The Realms of the Unreal* after 1932 is questionable. According to MacGregor, Volume X contains a reference to "the Crash of world's money market," dating the creation of that volume, at least in part, to no earlier than late 1929; see John M. MacGregor, *Henry Darger: In the Realms of the Unreal* (New York: Delano Greenidge Editions, 2002). He suggests, therefore, that the first nine volumes were written between 1911 and 1928 and deduces that the remaining volumes were completed by 1938 or 1939, since Darger embarked on *Further Adventures in Chicago: Crazy House* in 1939 (according to a reference in a letter MacGregor found among Darger's belongings). The museum dates the entire manuscript 1910–1938/9. Further information and a new analysis by Bonesteel will be available in a forthcoming publication, *Henry Darger's Story of the Vivian Girls in the Realms of the Unreal, Book One: The Child-Slave Rebellion* (2015).

13. For instance, let us think of Charles Shannon, applied to the case of Bill Traylor. In this art field, a history of the titles given to the works by collectors and dealers should be put in perspective.

14. Very few works made by women in psychiatric hospitals survived before the second half of the twentieth century, probably because these creations—textile works in particular—were at that time generally not

considered to be works of art, unlike the traditional techniques of painting and drawing.

15. Archives Marino Auriti, American Folk Art Museum, New York.

16. Claude Lévi-Strauss, *La pensée sauvage* (Paris: Plon, 1962).

17. The immigrant figure can be seen as a "bricolage" made of the remnants of his culture of origin and the fibers of his receiving country. He occupies an intermediate space, unrooted and secluded, which can provide comforts and extreme tensions. He is at the same time freed of and invested with the weight of his tradition. Immigration is a solitary, transformative process, toward a future to be invented. Assimilation, acculturation, alternation, multicultural, and fusion models have been used to describe the psychological processes, social experiences, and individual challenges and obstacles of being bicultural. The case of Martín Ramírez, as well as many self-taught artists, can be approached through that lens. The restoration of a sociological and cultural context brought the sociologists Víctor M. Espinosa and Kristin E. Espinosa to study his work not as the isolated artifact of a "troubled mind" but as the product of a displaced immigrant who had accumulated a number of aesthetic and technical influences throughout his difficult life. The images of his past resurface intensively. See Víctor M. Espinosa and Kristin E. Espinosa, "The Life of Martín Ramírez," in Brooke Davis Anderson, *Martín Ramírez* (Seattle, WA: Marquand Books in association with American Folk Art Museum, 2007), 19–39.

18. Caelan Mys, "Eugene Von Bruenchenhein," Kinz + Tillou Fine Art, http://www.ktfineart.com/current/?object_id=128&show=press&pressid=319.

19. Michel Thévoz, interview by the author, April 13, 2006.

20. Valérie Rousseau, "The Object's Potentiality: At the Source of Outsider Art Environments," in *Used/Goods: Cut Rate Collective*, eds. Giselle Amantea et al. (Montreal: Cut Rate Collective, 2009), 177–89.

21. William Hawkins, 4:39, in *William Hawkins Born KY July 27 1895* (New York: Breakaway Films in association with Foundation for Self-Taught American Artists, 2010), filmed c. 1987, Vimeo video, 7:44, posted by Zach Wolf, August 17, 2010, https://vimeo.com/14214264.

22. Jean-Louis Lanoux, "Les Prodiges du fil," *Montreuil California, 5 créateurs du Creative Growth Art Center/abcd, the journal* 3 (April 2007).

23. Ralph Fasanella, quoted in Paul S. D'Ambrosio, "Subway Riders: A Gift to the Museum," *Folk Art* 20, no. 2 (summer 1995): 29.

24. William Hawkins, in *William Hawkins*, 6:06.

25. Even though they were not created as part of an art environment per se, Ralph Fasanella's large paintings were intended to be displayed in public areas, sustaining his ambition to reach out to the masses. He had a clear sense of the audience he was targeting. "I didn't paint my paintings to hang in some rich guy's living room. They are about people and they should be seen by people—not hidden away." Highly politicized, the artist was preoccupied with community rather than individual introspection. He was celebrating, through his art, major social realities, lamenting inequality. Alice L. Powers, "Folk Art with an Urban Edge," *Americana* 19 (May–June 1991): 59.

26. This quote and the preceding one are taken from interviews with Mary T. Smith, Elizabeth Alexander, and S. L. Major by William S. Arnett in 1986, 1987, 1988, and 1995; Souls Grown Deep Foundation, http://soulsgrowndeep.org.

27. Ray McDermott, "Materials for a Confrontation with Genius as a Personal Identity," *Ethos* 32 (June 2004): 282, http://www.jstor.org/stable/3651837.

28. This definition evolved toward our contemporary understanding of the term: the "genius" is associated with an intrinsic personal characteristic, attributed to someone with naturally brilliant intelligence or talent.

29. Michel Thévoz, *Collection de l'Art Brut, Lausanne* (Zurich: Institut suisse pour l'étude de l'art, 2001), 11–13.

30. William Edmondson, quoted in Maridean Hutton, "Dialogues with Stone: William Edmondson, Ernest 'Popeye' Reed, and Ted Ludwiczak," *Folk Art* 21, no. 1 (spring 1996): 46.

31. Caelan Mys, "Eugene Von Bruenchenhein."

32. Archives Marino Auriti, American Folk Art Museum, New York.

33. Michel Thévoz, interview by the author, April 13, 2006.

34. Judith McWillie, "J. B. Murray Transcript," Folk Streams, http://www.folkstreams.net/pub/ContextPage.php?essay=1015.

35. George Widener, interview by the author, spring 2013.

36. Bernard L. Herman, "Bill Traylor Reporting," in *Bill Traylor: Beyond the Figure* (proceedings), ed. Valérie Rousseau (New York: American Folk Art Museum, 2014).

37. Alissa Quart, *Republic of Outsiders: The Power of Amateurs, Dreamers, and Rebels* (New York: New Press, 2013).

ASPIRATION

BUILDERS

SELF-DETERMINATION

CONSUMMATION

RISING

DEFIANCE

CHALLENGE

CERTITUDE

ACHiEVERS

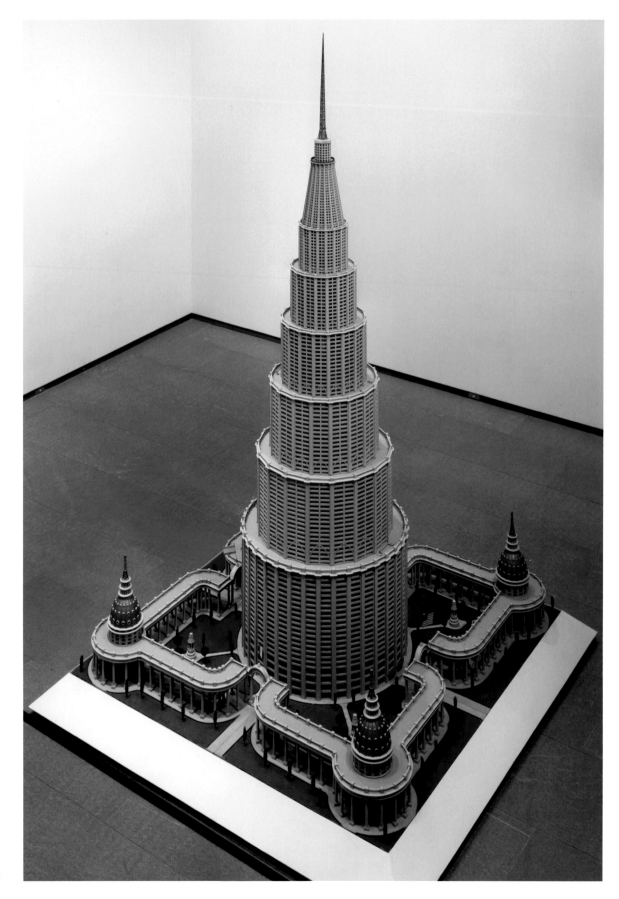

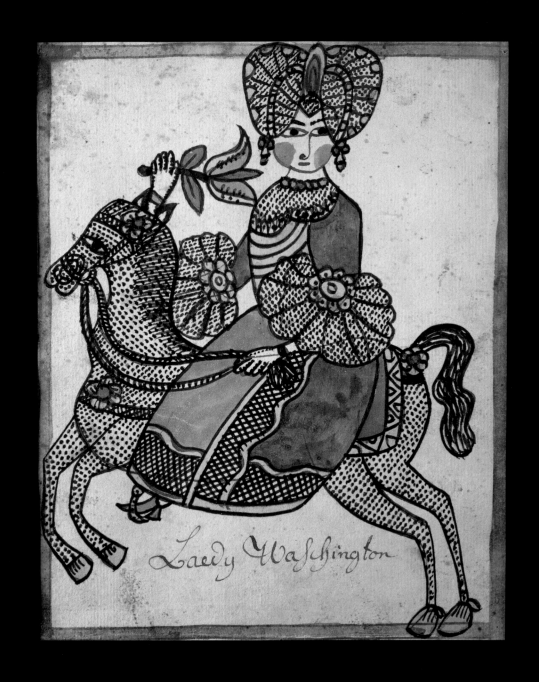

Laedy Washington

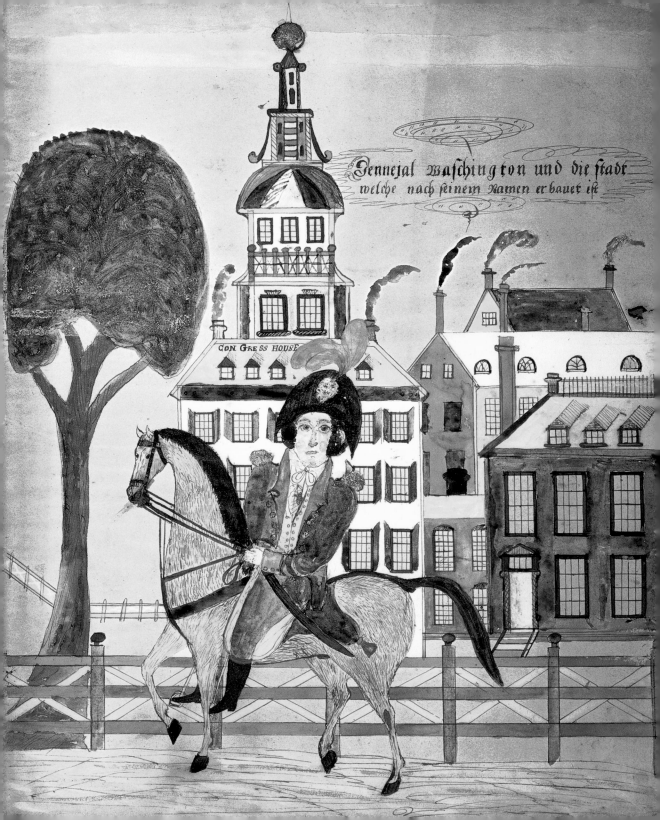

Gennejal Waschington und die Stadt
welche nach seinem Namen erbauet ist

CON GRESS HOUSE

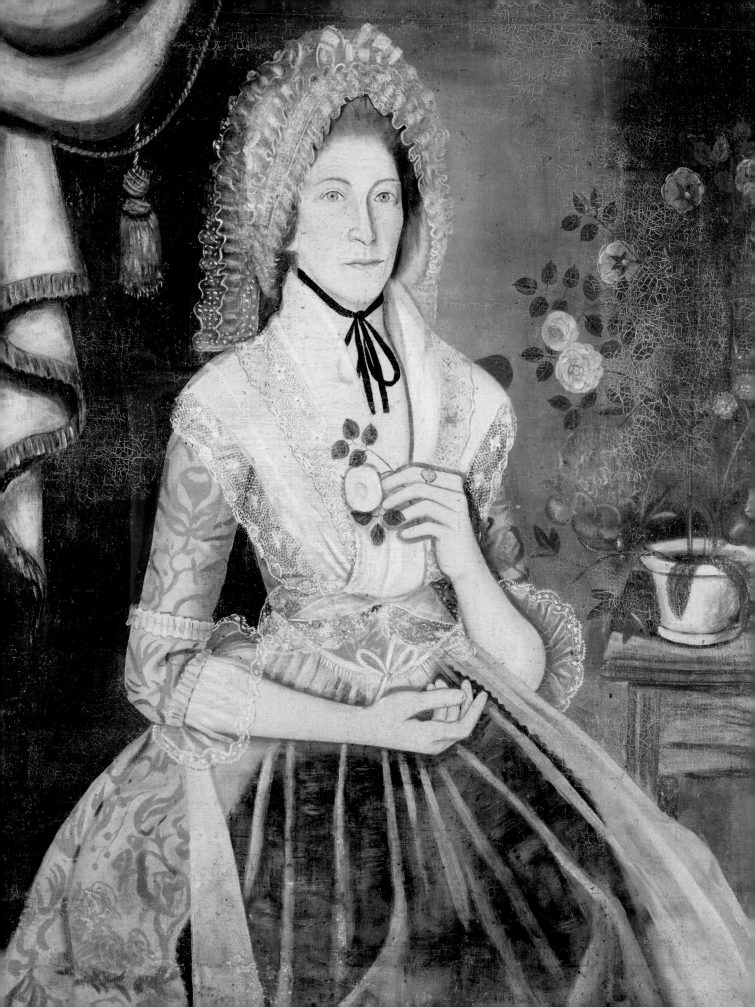

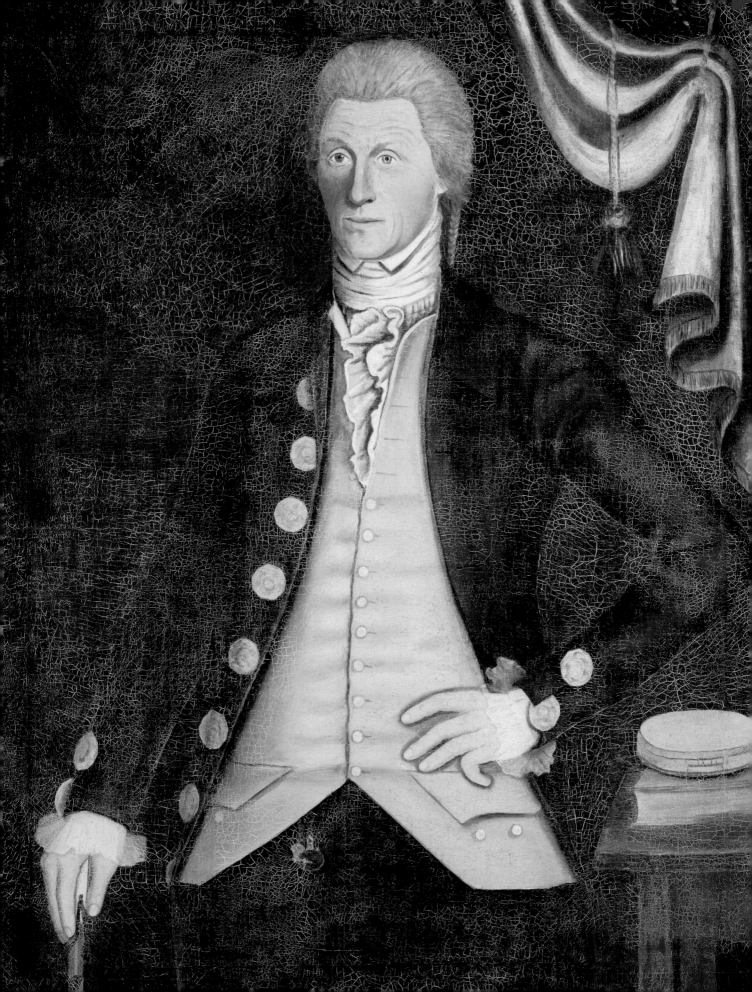

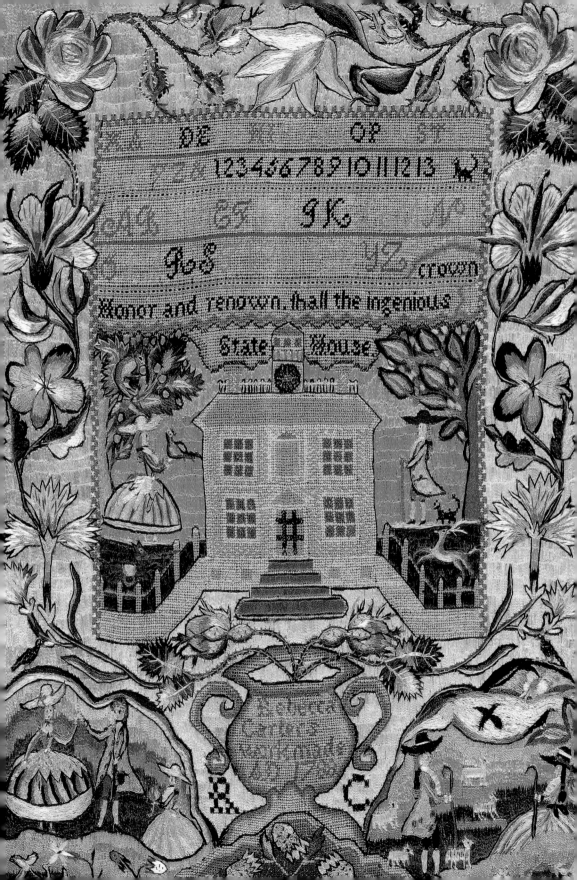

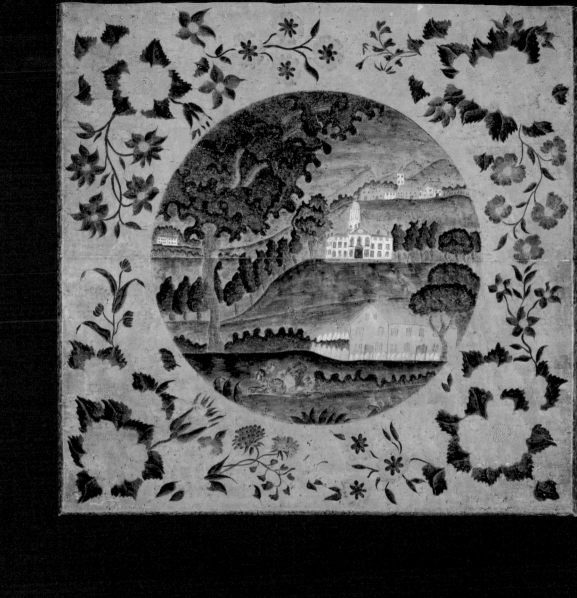

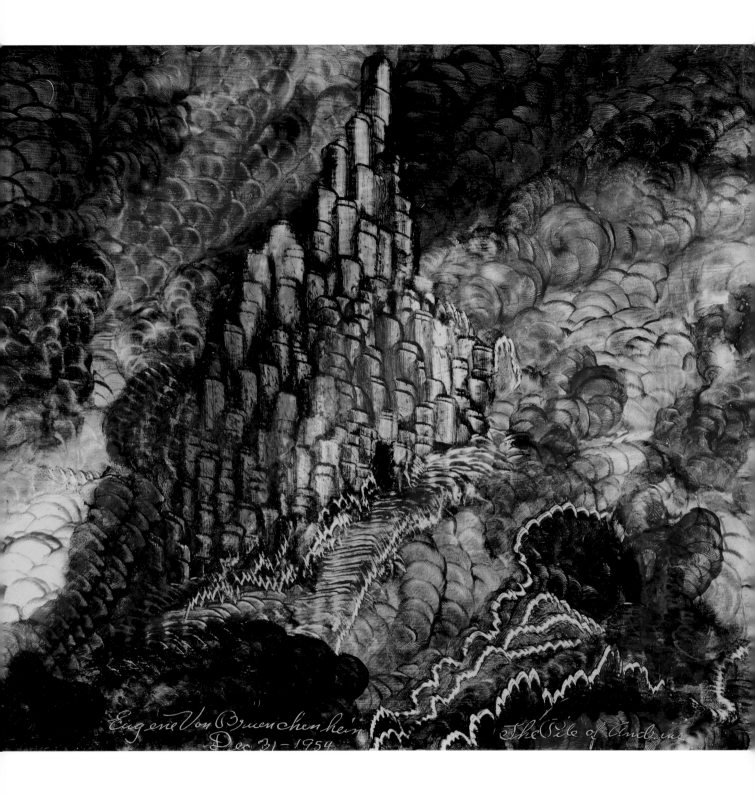

Eugene Von Bruenchenhein
Dec 31 - 1954

The Isle of Andreas

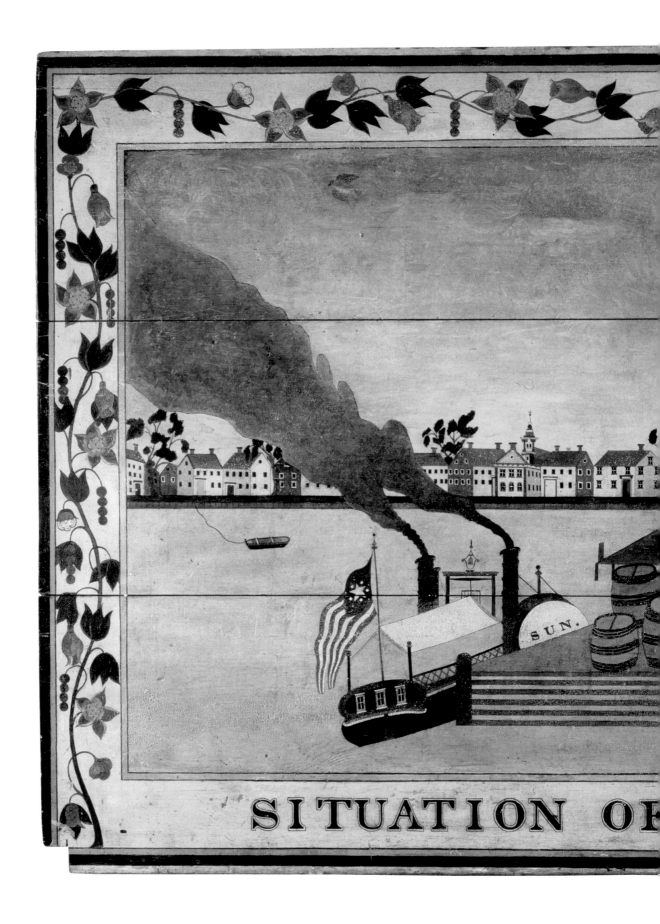

SITUATION OF

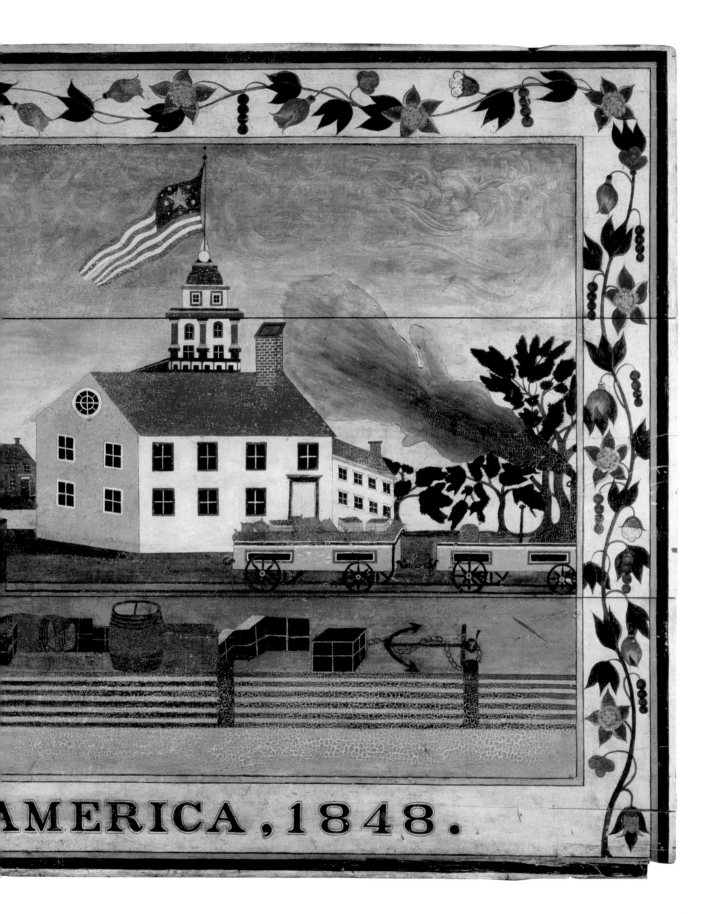

AMERICA, 1848.

The Kathredal

EAST ELEVATION

THE 1st 20 YEARS

RATING
SYMBOLIZATION — 90%
COMPOSITION — 75%
DRAFTSMANSHIP — 80%
RENDERING — 40%

GATEMAN

INFORMANT

MOTHER SYMBOLICALL
BIRTHDAY GREETINGS NOV. 11, 1936.
A Picture of My Beautiful, Beautif

RESENTED

Mother

SENTRY POST No 2

THE WORLD ONE FAMILY OY LOVE

CARPPITTAN, GRANDJCOSTI
AND COPANHAGEN, DELS.
REQUESTED BY A.G. RIZZOLI

PAGE **68–69**
Encyclopedic Palace/*Palazzo Enciclopedico/*
Palacio Enciclopedico/Palais Encyclopédique or
Monumento Nazionale. Progetto Enciclopedico
Palazzo (U.S. patent no. 179,277)
MARINO AURITI (1891–1980)
Kennett Square, Pennsylvania
c. 1950s
Wood, plastic, glass, metal, hair combs,
and model kit parts
11 × 7 × 7'
Gift of Colette Auriti Firmani in memory
of Marino Auriti, 2002.35.1

PAGE **70**
Laedy Waschington
THE SUSSEL-WASHINGTON ARTIST
Possibly Berks County, Pennsylvania
c. 1780
Watercolor and ink on paper
7¾ × 6¼"
Gift of Ralph Esmerian, 2005.8.41

PAGE **71**
Genneral Waschington
ARTIST UNIDENTIFIED
Southeastern Pennsylvania
c. 1810
Watercolor, gouache, ink, and metallic paint
on paper
9⅝ × 8"
Gift of Ralph Esmerian, 2013.1.35

ACHIEVERS

PAGES 72–73
Mary Kimberly Thomas Reynolds
James Blakeslee Reynolds
ATTRIBUTED TO REUBEN MOULTHROP
(1763–1814)
West Haven, Connecticut
c. 1788
Oil on canvas
45¼ × 36" each
Gift of Ralph Esmerian, 2013.1.1, 2

PAGE 75
Rebecca Carter Sampler
REBECCA CARTER (1778–1837)
Providence, Rhode Island
1788
Silk, metallic thread, and human hair
on linen, in original frame
19¼ × 13½" (sight)
Gift of Ralph Esmerian, 2013.1.47

PAGES 76–77
Worktable
ARTIST UNIDENTIFIED
New Hampshire; possibly West Nottingham
c. 1819
Watercolor, pencil, and ink on bird's-eye
maple
28⅝ × 18⅝ × 18"
Gift of Ralph Esmerian, 2005.8.50

PAGE 78
The Pile of Andrius (#67)
EUGENE VON BRUENCHENHEIN (1910–1983)
Milwaukee, Wisconsin
December 31, 1954
Oil on corrugated cardboard
13 × 15½"
Gift of Lewis and Jean Greenblatt, 2000.1.24

PAGE 79
Gold Tower
EUGENE VON BRUENCHENHEIN (1910–1983)
Milwaukee, Wisconsin
c. 1970s
Paint on chicken bones and turkey bones
35½ × 6 × 7"
Gift of Lewis B. Greenblatt, 1999.22.1

PAGE 80
Statue of Liberty Cabinet
TITUS ALBRECHT (OR TIDUS ALBRECH)
(DATES UNKNOWN)
Vicinity of St. Louis, Missouri
c. 1886–1890
Wood cutouts and paint on wood
77¾ × 30⅜ × 21⅛"
Gift of the Hirschhorn Foundation, 1997.6.2

PAGE 81
Empire State Building
ARTIST UNIDENTIFIED
New Jersey
c. 1931
Cherry
94 × 30 × 30"
Museum purchase made possible through the
generosity of the Briskin Family Fund in
honor of Frank Maresca, 1999.3.1

PAGES 82–83
Situation of America, 1848.
ARTIST UNIDENTIFIED
New York City
1848
Oil on wood panel
34 × 57 × 1⅜"
Gift of Ralph Esmerian, 2013.1.21

PAGES 84–85
Mother Symbolically Represented/
The Kathredal
ACHILLES G. RIZZOLI (1896–1981)
San Francisco, California
1936
Ink on rag paper
27¾ × 47⅝"
Promised gift of Audrey Heckler, P1.2013.1

ABSTRACT

CODE

CONCEAL

DISSIMULATE

HIDE

DENY

ENCAPSULATE

ENCRYPTION

ENCODeRS

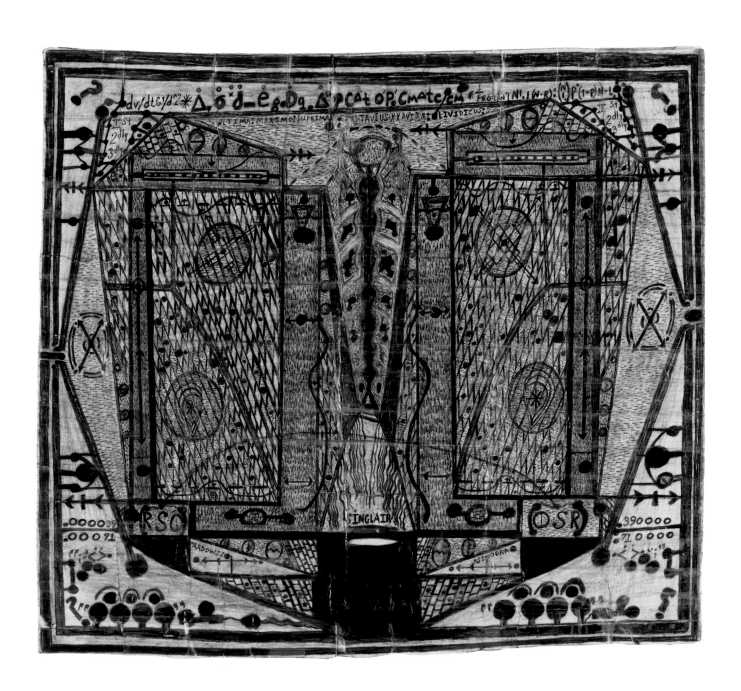

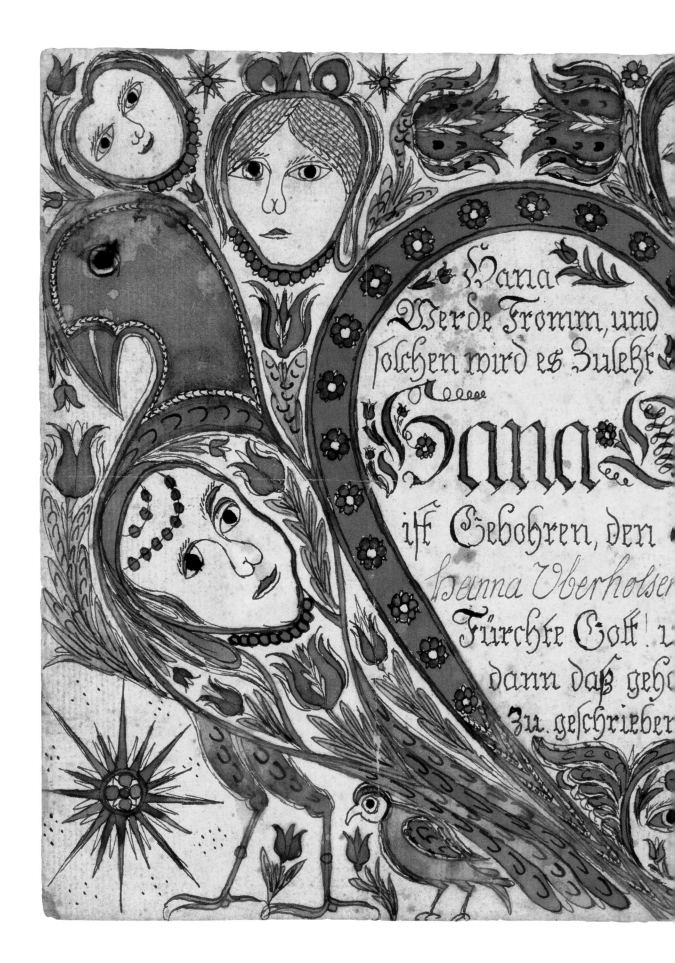

Hana
Werde Fromm, und
folchen wird es zulekt

Hana
iff Gebohren, den
hanna Vberholser
Fürchte Gott! i
dann das geho
zu geschrieber

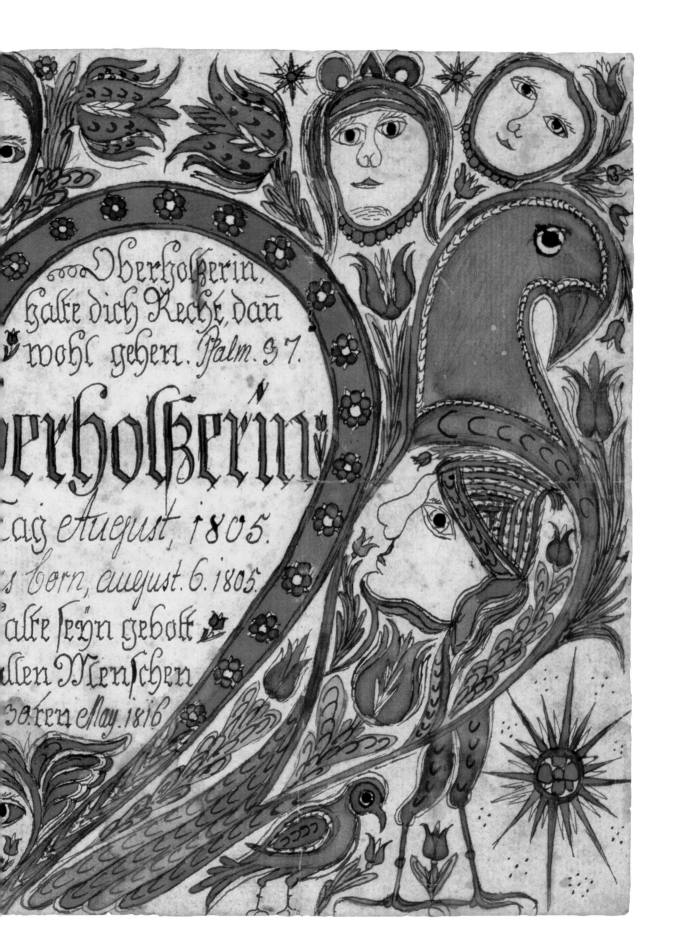

Oberholzerin,
halte dich Recht, dañ
wohl gehen. Psalm 97.

berholzerin

ag August, 1805.

born, august. 6. 1805.

alte seyn gebott

llen Menschen

30. ten May. 1816

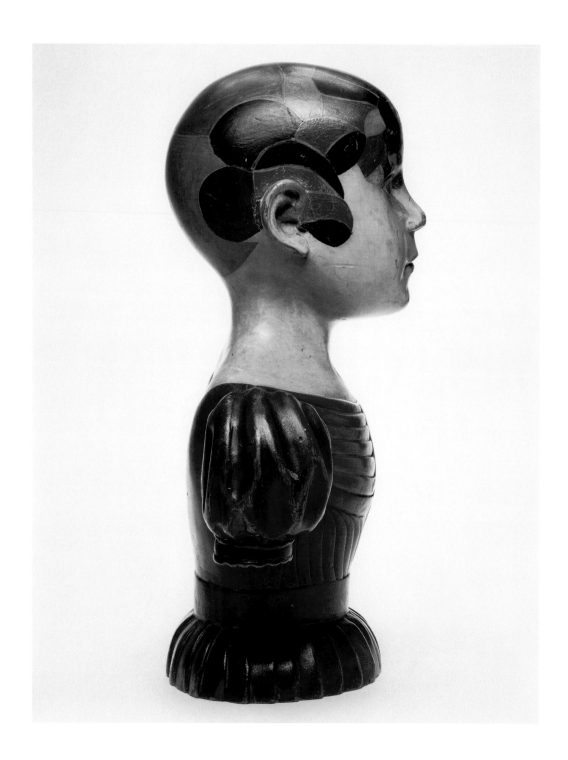

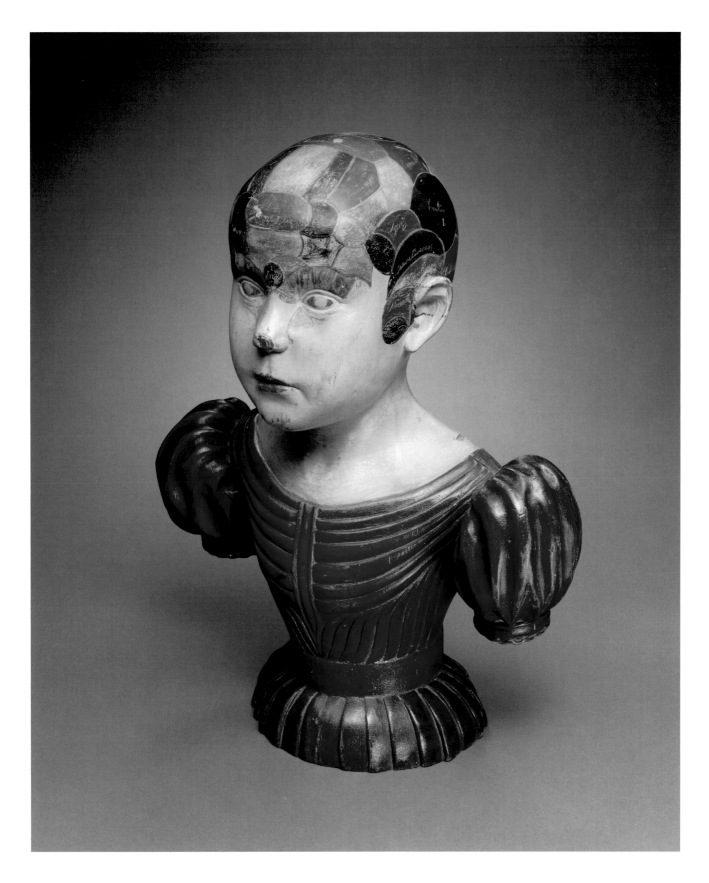

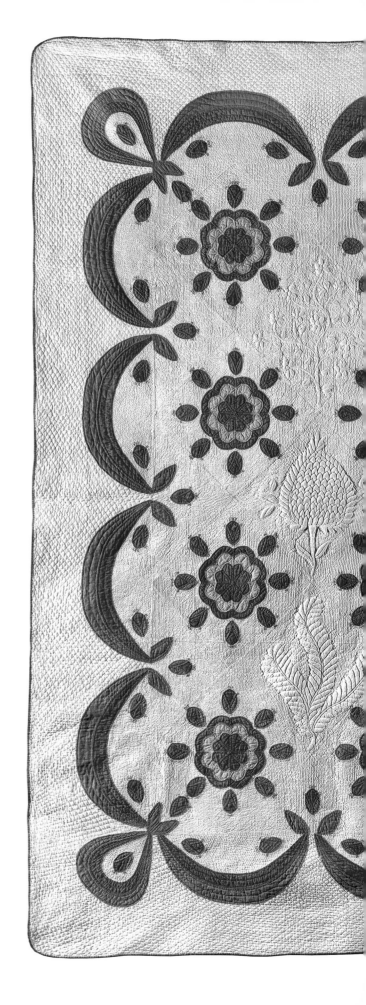

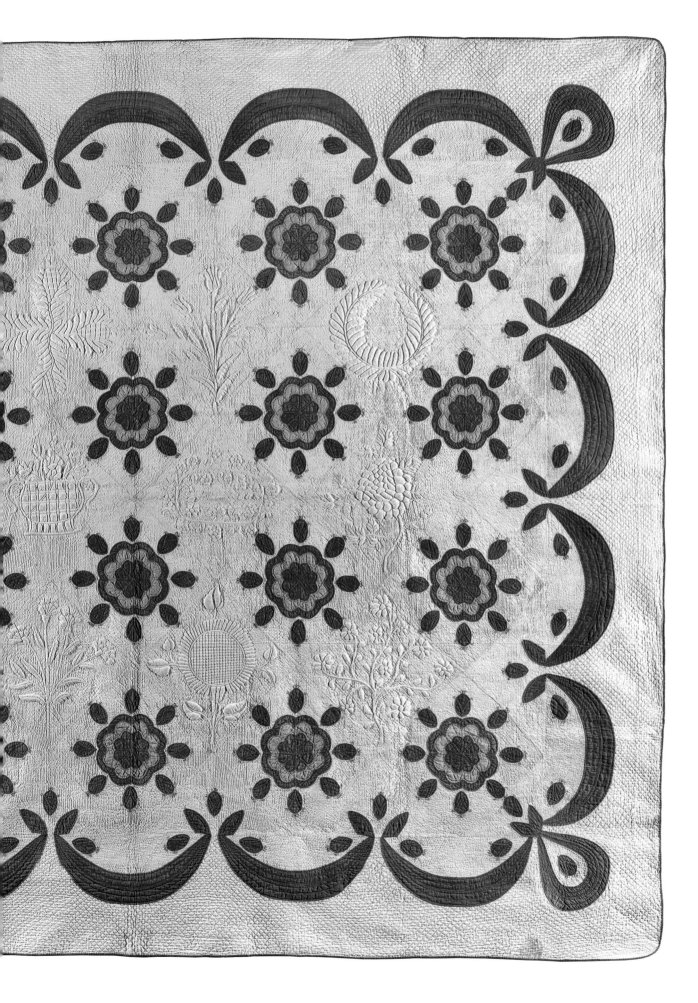

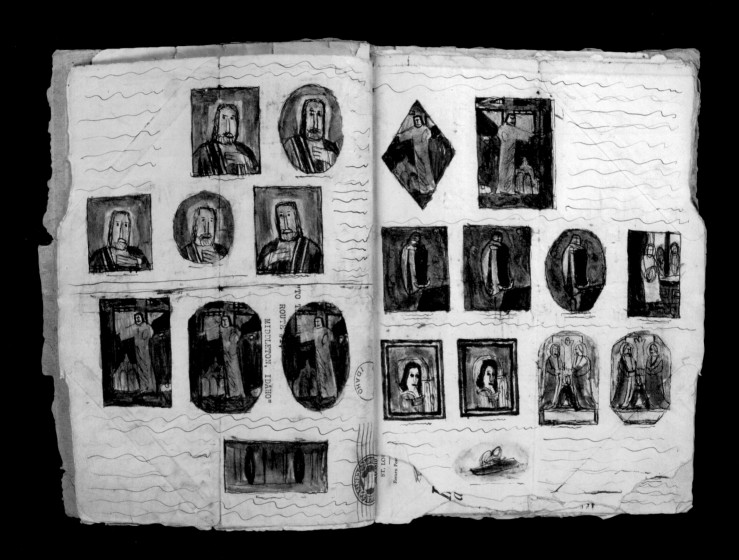

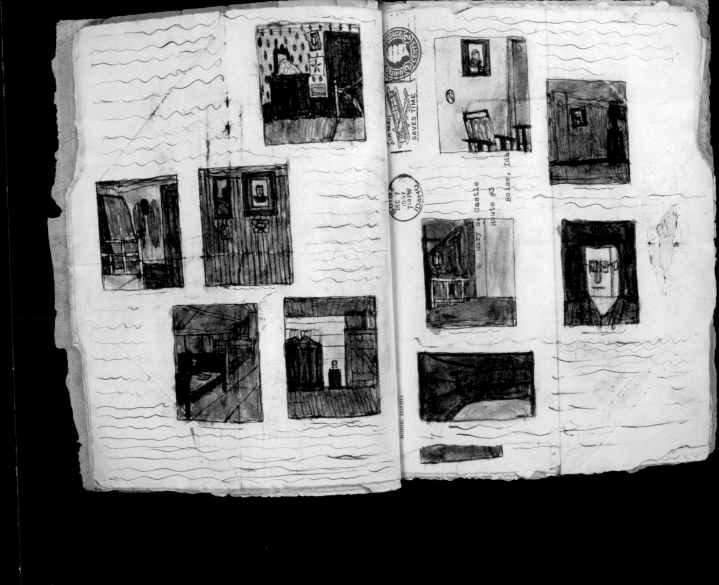

The History of
my life. By Henry
Joseph Darger, (Dargarius?
or Brazilian) '851 Webster
ave, Chicago Ill. Box 14,

In the month of april,
on the 12, in the year
of 1892, of what week day?
never knew as I was never
told, nor did I seek the
information.

Also I do not remem-
ber the day my mother
died, or who adopted my
baby sister, as I was then
too young, nor who my
uncle Charles would tell
me or did not know
either,

My father and I lived
in a small two story
house, on the south side
of a short alley between
Adams and Monroe street.
Aross on Monroe on
the streets north side
were two large high
schools one a little.

THE STORY OF THE BRAVERY OF THE
VIVIAN GIRLS, CALLED VIOLET , AND HER SISTERS, IN ''''
THE REIGN OF TERROR, OR THE GREAT GLANDCO- ANGELINIAN WAR....

INTRODUCTION:

 This description of the great war, and its following
results, is perhaps the greatest ever written by an author, on the line of any
 fabolus war,,that could ever be intitled, with such a nae name,.The war
lasted about four years and seven months in this story,, and the
 author of this book has taken over eleven u years in writing out the long
and graphic details, and has fought on fron day, to day, in order to win
for the christ ian sd side this long and bloody war, and though the christ
ians had been threatened with defeat, on account of a strange Aronburg mystery
 which could not be solved by any one, not even myself, they finally won
when they turned the tide against the enemy at the frightful battle of
Aronburgs Run.
The Aronburg mystery as well as the murder of the Aronburg child, had threat
.ened the doom of the three christian states, for the whole length of the
 great Glandco Angelinian war, and it was predicted that the solving of the
Aronburg myste ry or for the revenge of her assassins,'was the only hope
for any chance of the christian nation winning the war. Abbieannia managed
to crush Glandelinia herself, after c Claverinia had been ruined, and '
almost destroyed, and Angelinian nation almost wiped out in her armies.

 By Henry Joseph Darger.
 The author of thrilling story.

The scenes of this story as its title indicates, lies among the nations
of an unknown or imaginary world or countries, with our earth as their moon,
though there are two big islands belonging to Glandelinia that well form
the shapes of our c lands. The names of these nations are Angelinia,
Abyssinkile, Protestentia, and Abbieannia four great Catholic nations,
 there being no protesteant nations.Other Catholic nations but rivals of
Glandelinia also are, Mormonuia, Hickenile, Hickencile,, Condemnoncda,
Glandlina, Spoonmia, Croetoria, Madorria, Claresinia, and Pruetinia.
Next to Abbieannia Glandelinia is the most powerful of them all, and three
quarters of the population are as wicked as wickedness can be.There are scores
of other nations, but their names are not given. The two nations Glandelinia,
and Abbieannia, alone have in this story hundreds of thrillions of men,
, many thrillions of women, and children.The namew of the Oceans are the same
as the nations,,,,,.
 THIS imaginary plandtis a thousand times as large as out own
world and the largest body of water known as the Angelinian seas, could hold
scores of our own worlds, and still have room.

Dry Measure

Ch	Bu	P		Ch	B	P
17 =	2 =	1		40 =	1 =	2
10 =	1 =	3 =		16 =	5 =	1
7 =	0 =	2 Ans		23 =	32 =	1

Qrs	B	P		Qrs	B	P
19 =	1 =	1		26 =	1 =	3
12 =	7 =	2		19 =	1 =	2
6 =	2 =	3 Ans		7 =	0 =	1

Time

D	H	M	S	60	D	H	M	Sec
41 =	13 =	22 =	13		14 =	1 =	10 =	12 = 10
22 =	16 =	33 =	31		10 =	3 =	19 =	48 = 26
18 =	20 =	48 =	41	A	3 =	4 =	15 =	23 = 44

W	D	H	M	Sec
17 =	1 =	10 =	12 =	10
10 =	2 =	14 =	6 =	15
6 =	5 =	20 =	5 =	55 Ans

Motion

o	'	''		o	'	''
48 =	10 =	12		47 =	2 =	10
12 =	11 =	16		12 =	19 =	46
28 =	58 =	56	A	34 =	42 =	24 A

o	'	''
62 =	13 =	9
49 =	18 =	33
12 =	54 =	36

Answer John Whistler

Questions to exercise Sub:

1/ A Man was born in the year 1702 & Deman his age in the year 1767

1767
1702
Ans 65

2/ Their are 2 Numbers the greater Number is 61 & the lessor is 44 I demand the Difference Answer

61
44
17
Ans

3/ Their were 4 Bags of Money Containing as follows viz the first 34 L the 2th 50 L the 3th 100 L & the 4th 150 L which were to be Paid several Persons but 1 of the bags being left their were but 234 L paid I Demand which bag was left

L
34
50
100
150
334
234
100 Ans

4/ The Brewer and the Baker drew Bills Each upon the other the brewer stands indebted 45 L 19 S & the baker 26 L & 7½ d who is the person indebted & how much Answer

L S D
45=19=0
26=0=7½
19=18=4½

5/ King Charles the Martyr was beheaded in the year 1648 how many years is it since it

1810
1648
162

6/ A Man borrowed 30 L & paid in part 12 L 10 S I demand how much remains

L S D
30=0=0
12=10=0
17=10=0

7/ What Sum is that which taken from 100 L leaves 48 L 7 S 6½ d Answer

100=0=0
48=7=6½
51=12=5½

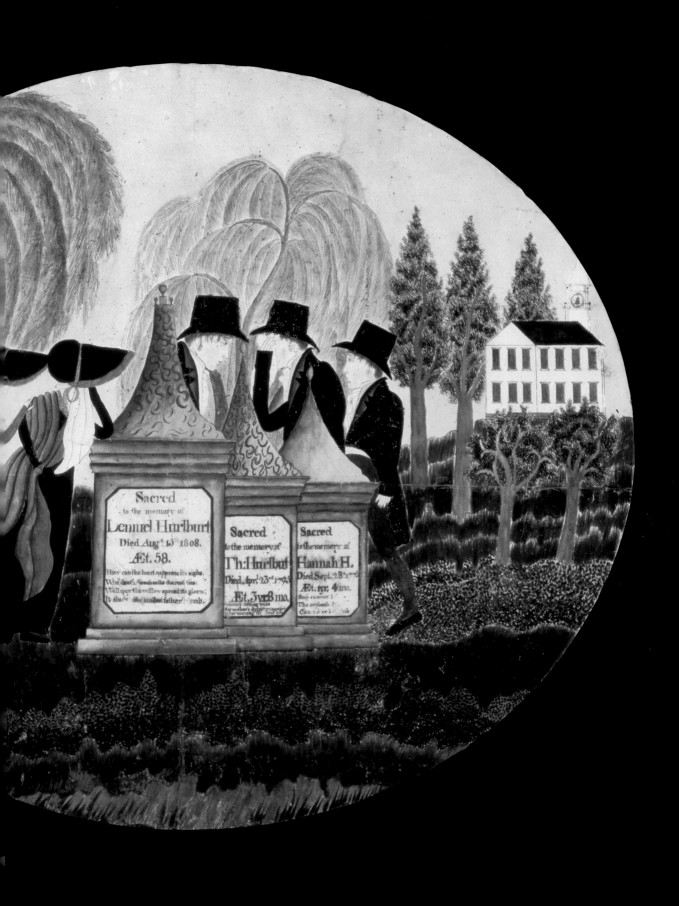

APRIL 16, 1912
THE WHOLE
WORLD CRIED
FOR HER
BLACK TUESDAY

R.M

1 2 3 4 5 6 7 8 9 10 11

SU

HIT
ICEBERG

MO

ALL
LOST

SANK ON MONDAY

MOURNED ON

TUESDAY

S. TITANIC

1ST CLASS
PASSENGER
GEORGE WIDENER

PAGE 91
Singlair
MELVIN WAY (B. 1954)
New York City
Late twentieth century
Colored pencil, pencil, and ink on paper, with scotch tape
19½ × 22"
Gift of Jacqueline Loewe Fowler, 2009.3.1

PAGES 92–93
Birth Record for Hana Oberholtzer
DAVID CORDIER (ACTIVE C. 1805–1820)
Miami River Valley, Southwestern Ohio
1816
Watercolor and ink on paper
7¾ × 12¼"
Gift of Ralph Esmerian, 2005.8.34

PAGES 94–95
Phrenological Head
ASA AMES (1823–1851)
Evans, New York
c. 1850
Paint on wood
16⅜ × 13 × 7⅛"
Bequest of Jeanette Virgin, 1981.24.1

PAGE 97
Untitled
JOHN BUNION (J. B.) MURRAY (1908–1988)
Sandersville, Georgia
Late twentieth century
Pen, ink, crayon, and watercolor on paper
14 × 10⅜"
Gift of Thea Westreich and Ethan Wagner, 2006.20.1

PAGE 99
Whig Rose and Swag Border Quilt
UNIDENTIFIED SLAVES; MADE FOR
MRS. MARMADUKE BECKWITH MORTON (1811–1880)
The Knob, Morton Plantation, Russellville, Kentucky
c. 1850
Cotton
88 × 104"
Gift of Marijane Edwards Camp, 2012.8.1

PAGES 100–101
Handmade Book
JAMES CASTLE (1899–1977)
Boise, Idaho
1920–1950
Soot and saliva on found paper, bound with string
12 × 10³⁄₁₆" (closed)
Gift of Thomas Isenberg, 2001.32.1

PAGE 102
The History of My Life (volume I, unpaginated)
HENRY DARGER (1892–1973)
Chicago, Illinois
c. 1968–1973
Ink, tape, and collage on paper and cardboard
12 × 11¾ × 2⅜"
Gift of Kiyoko Lerner, 2004.1.4

PAGE 103
The History of My Life (volume VIII, cover)
HENRY DARGER (1892–1973)
Chicago, Illinois
c. 1968–1973
Ink, tape, and collage on paper and cardboard
11¾ × 9½ × 3"
Gift of Kiyoko Lerner, 2004.1.4

PAGES 104–105
The Story of the Vivian Girls, in What Is Known as the Realms of the Unreal, of the Glandeco-Angelinian War Storm, Caused by the Child Slave Rebellion (volume I, page 1 and cover)
HENRY DARGER (1892–1973)
Chicago, Illinois
1910–1938/39*
Ink on paper and cardboard
10 × 14½ × 3¾"
Gift of Kiyoko Lerner, 2004.1.4

* See page 64, note 12, for information about the dating of this manuscript.

ENCODERS

BELIEVERS

INSTRUMENTS

INTERMEDIARIES

FAITH

PROPHECY

ASCENSION

ENVOY

HEALER

MESSENGeRS

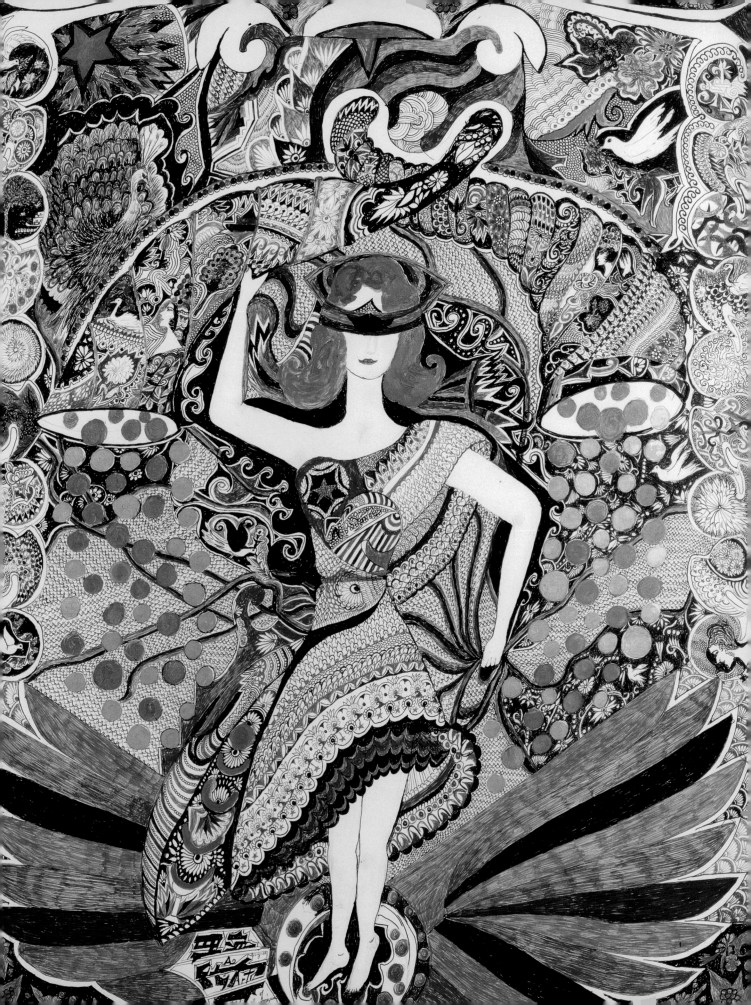

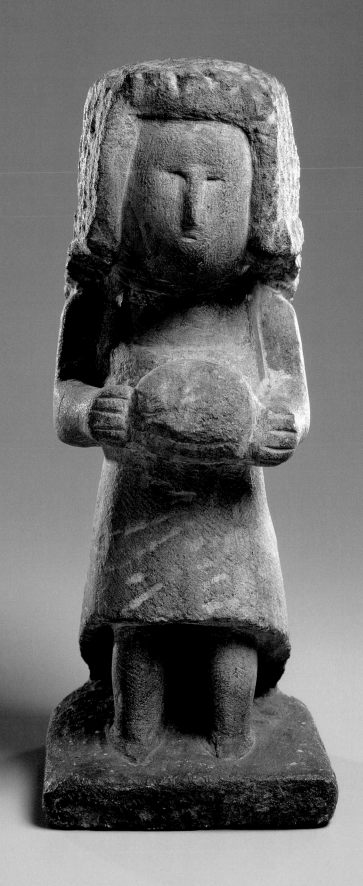

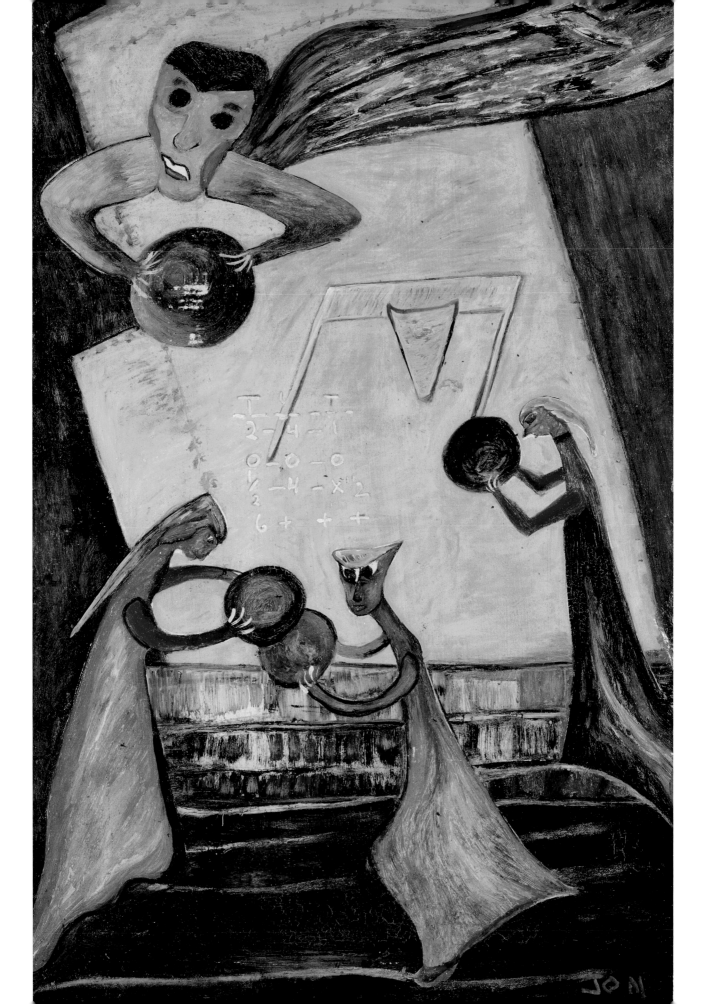

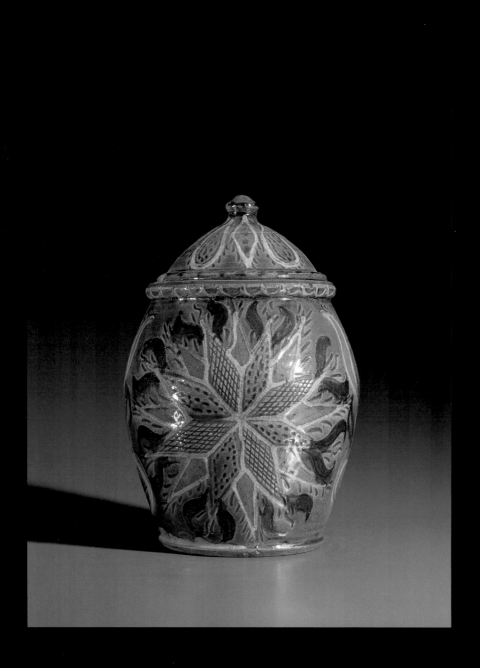

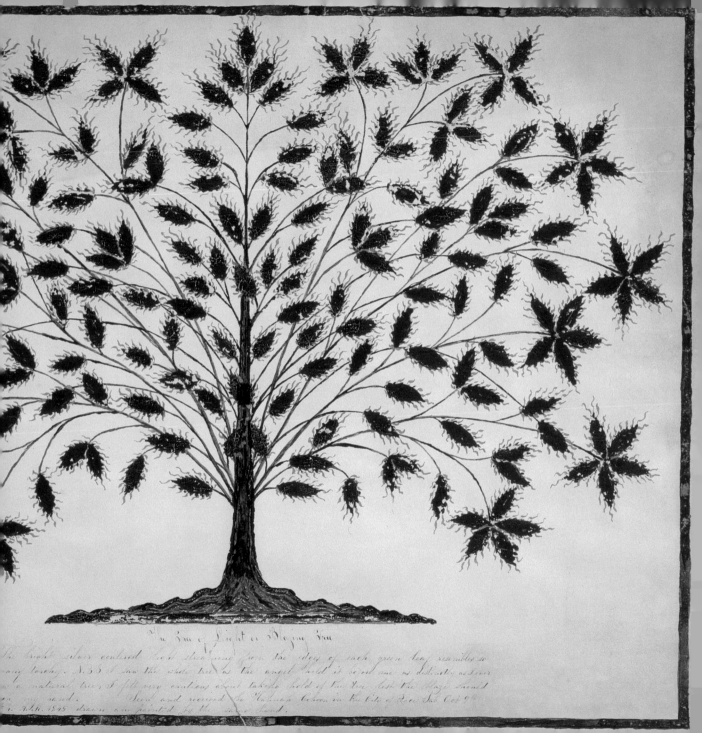

The Tree of Light or Blazing Tree

The bright silver coulered Wood streaming from the edges of each green leaf resembles so many torches. N. 55. I saw the whole tree as the angel held it before me as distinctly as I ever saw a natural tree, I felt very cautious about takeing hold of the tree lest the blaze should on my hand. Seen and received from Holman Cohoon in the City of Rochester Sab Oct 9th in Adlt 1845 drawn and painted by the same hand.

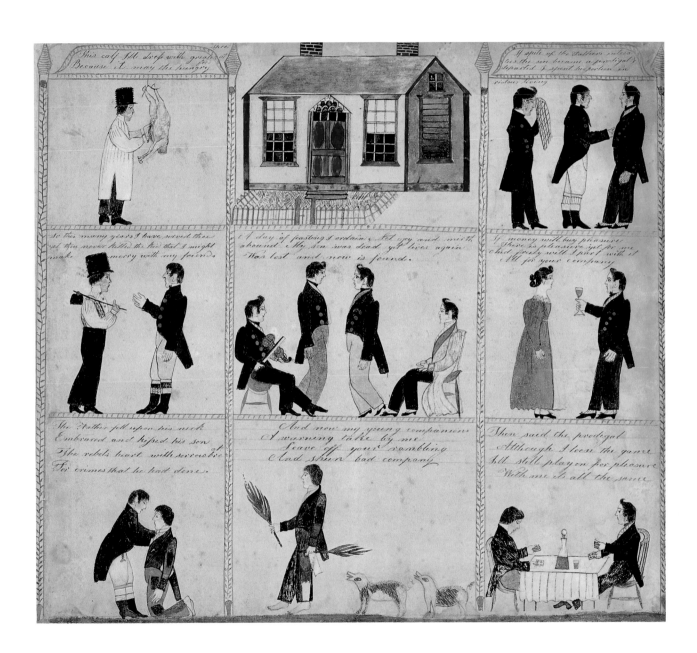

139

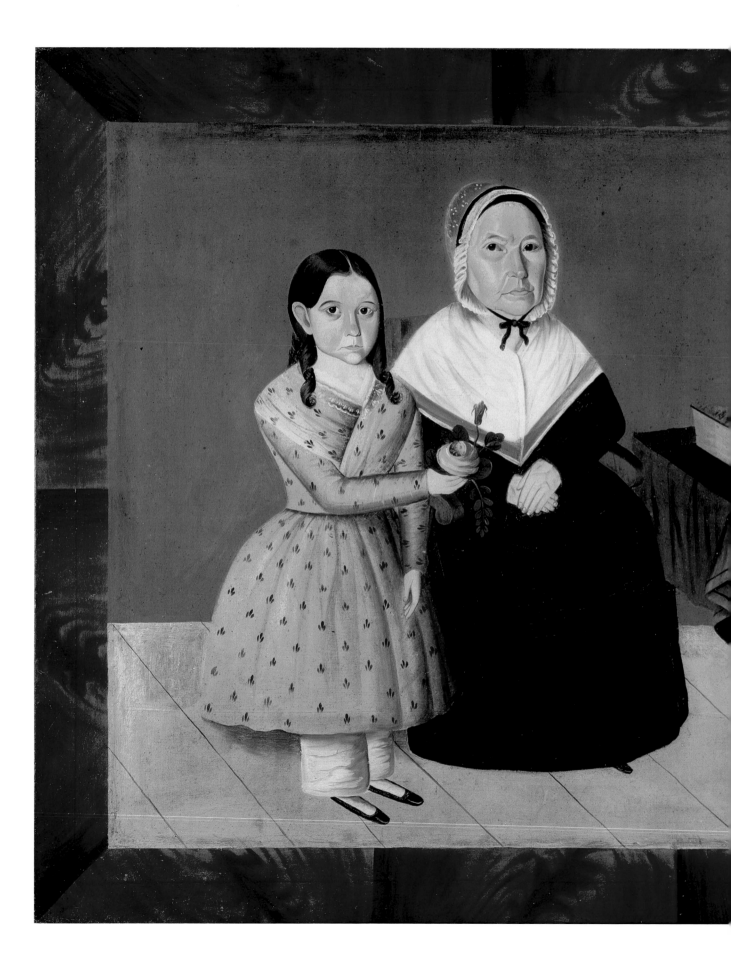

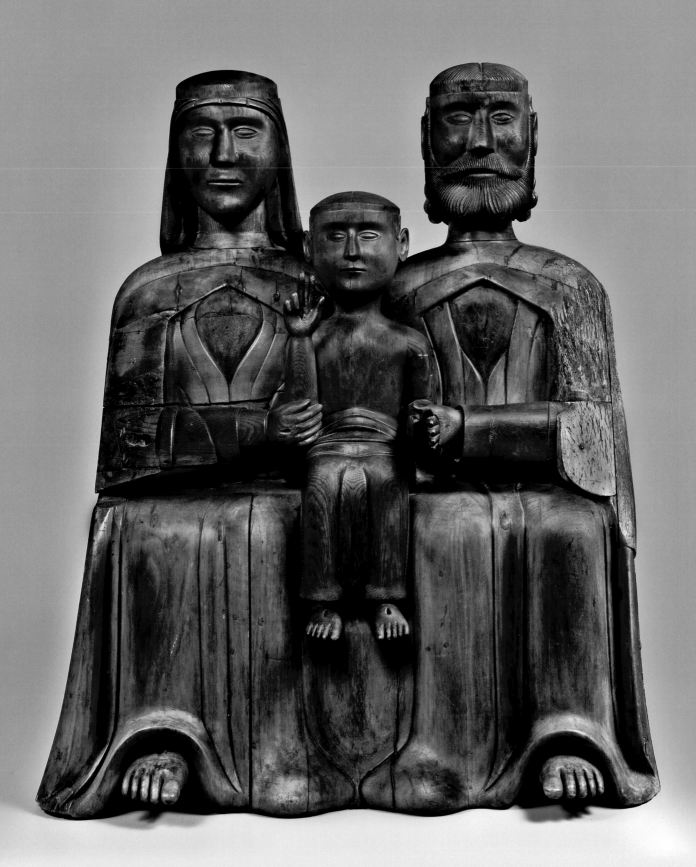

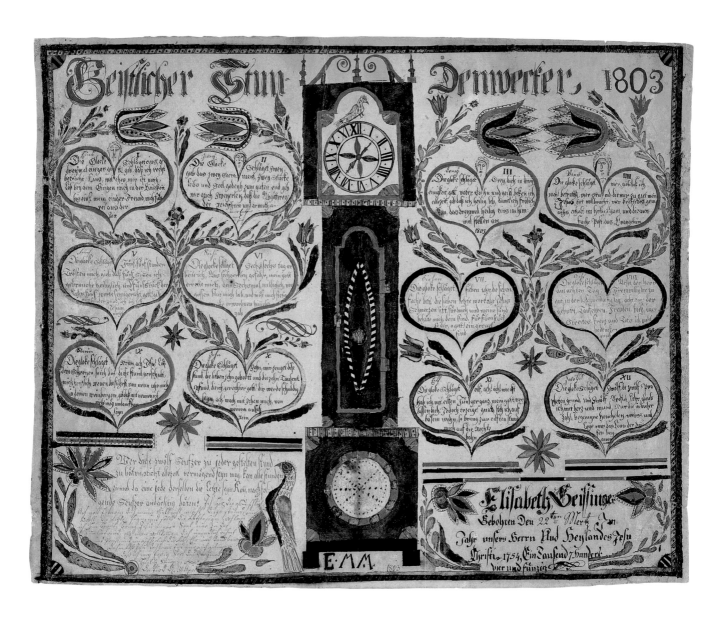

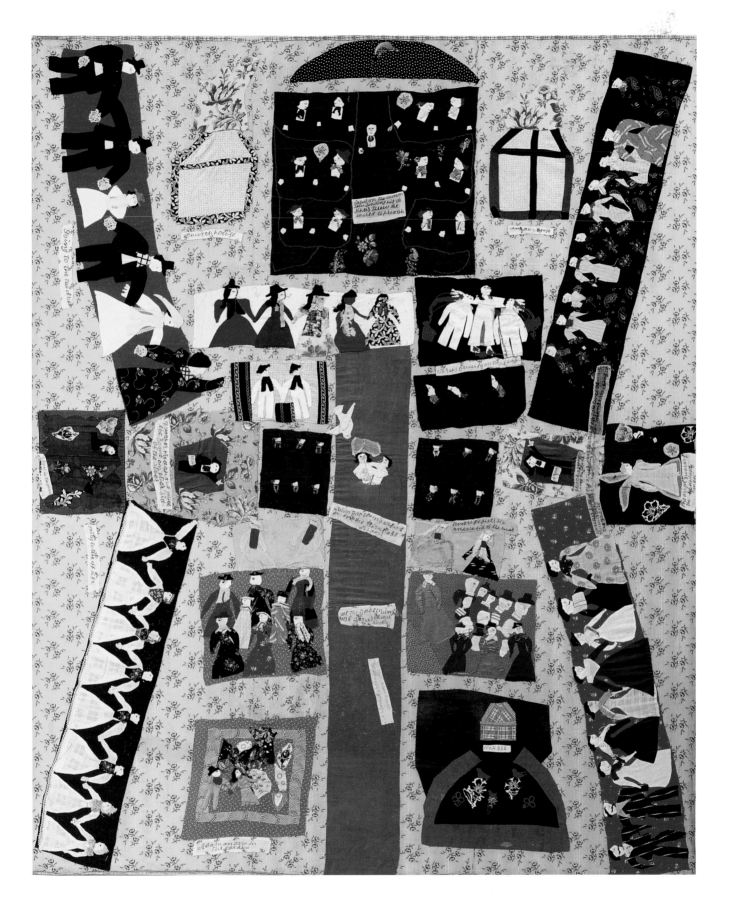

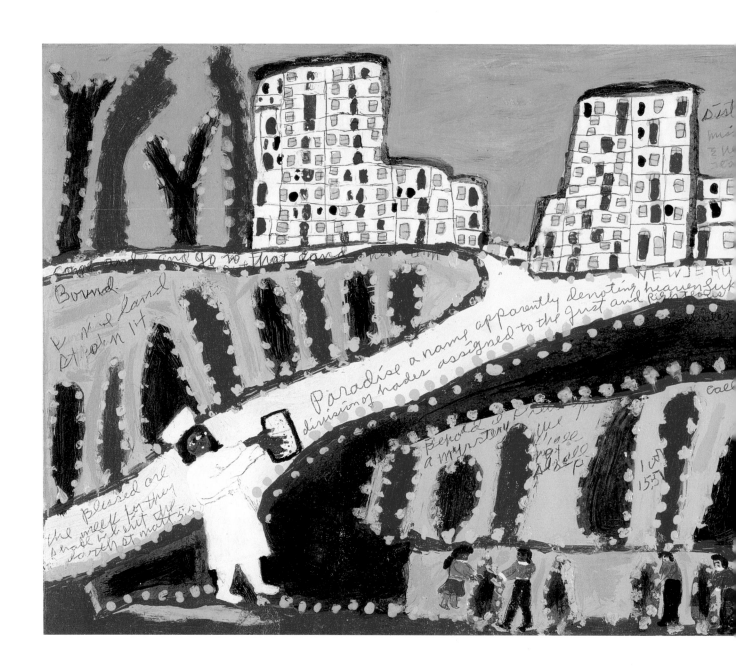

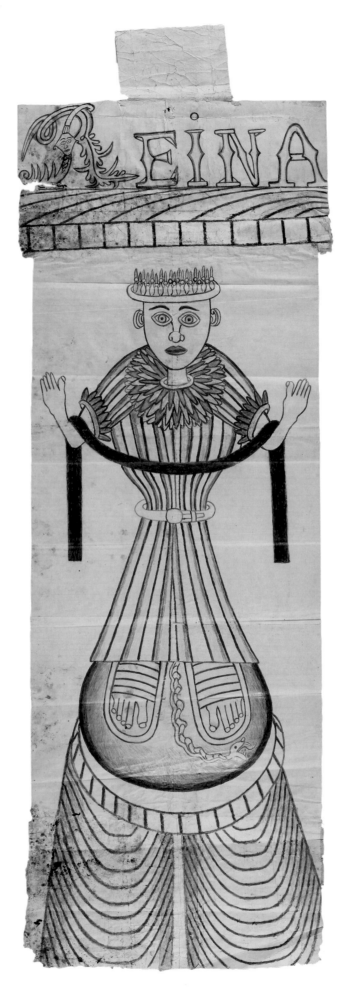

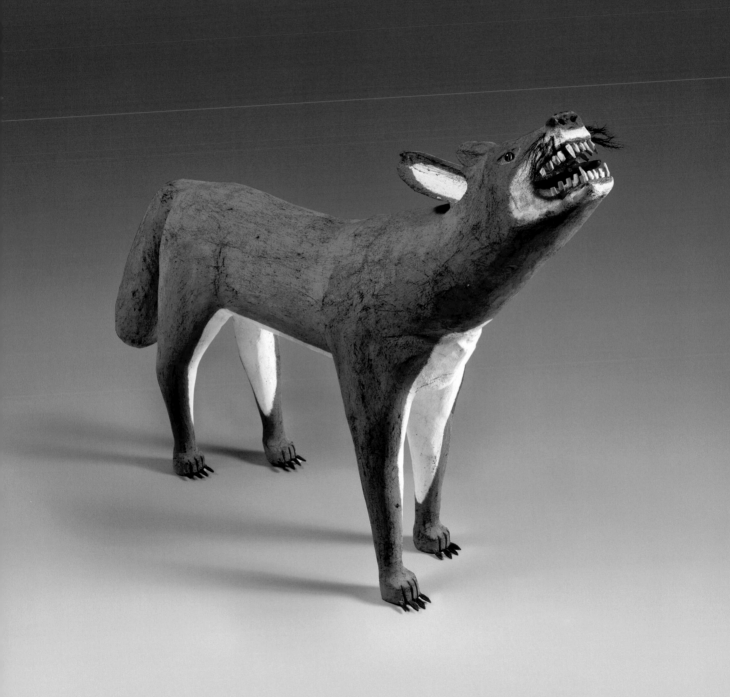

MESSENGERS

SELF-EDUCATION

SELF-REALIZATION

REPUBLICAN MOTHERHOOD

SOCIAL ORDER

INSTITUTIONS

ENTERTAINMENTS

ADVANCEMENT

OPTIMIST

IMPRoVEMENT

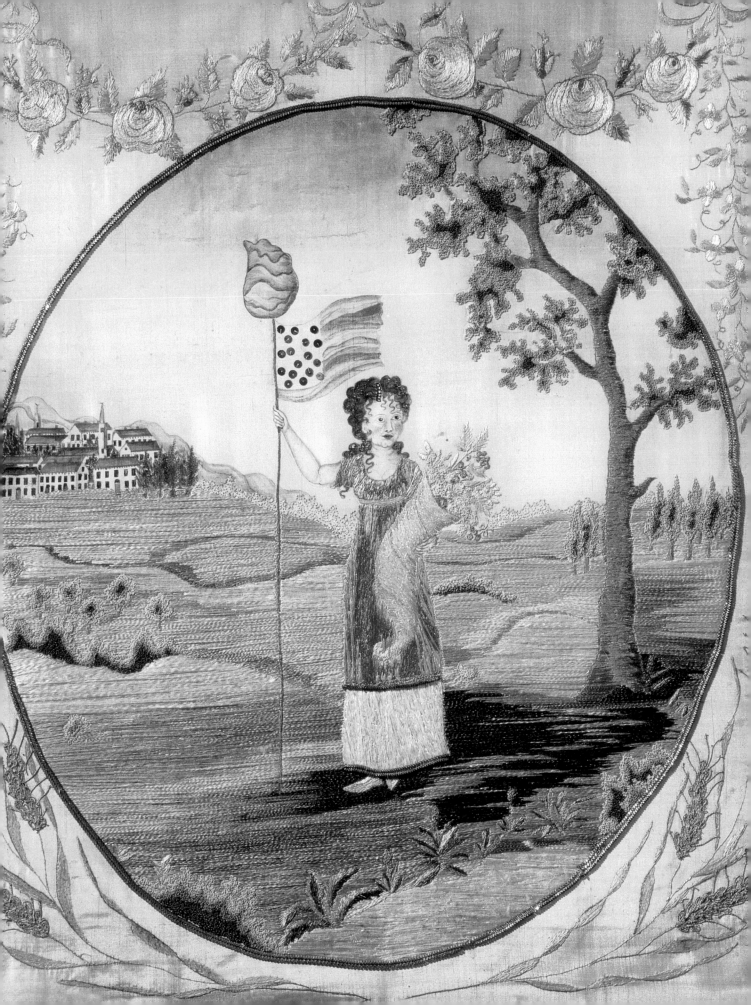

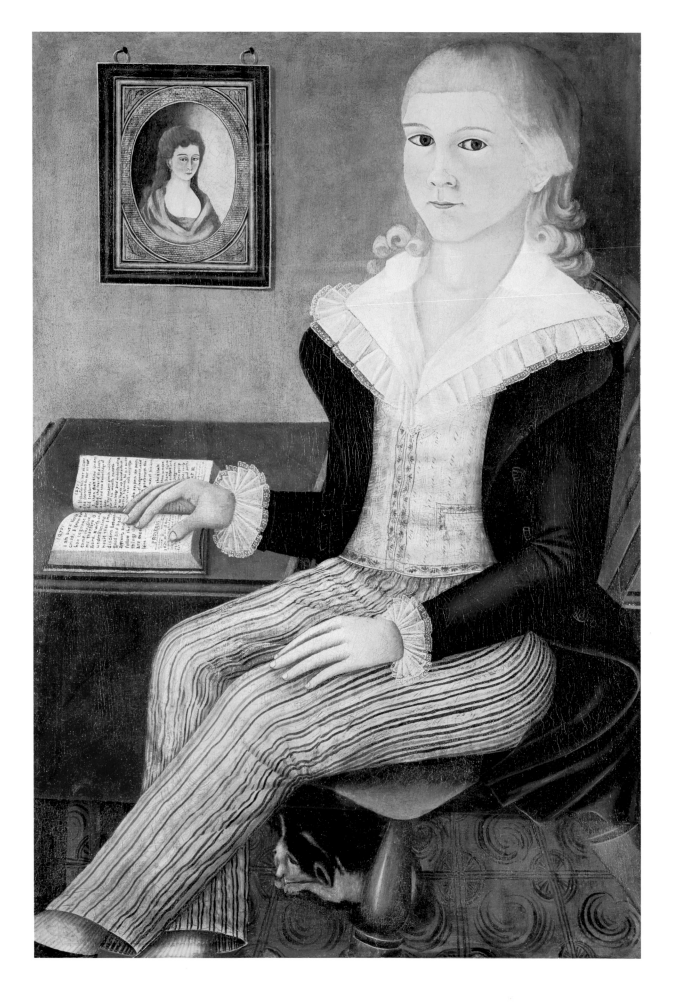

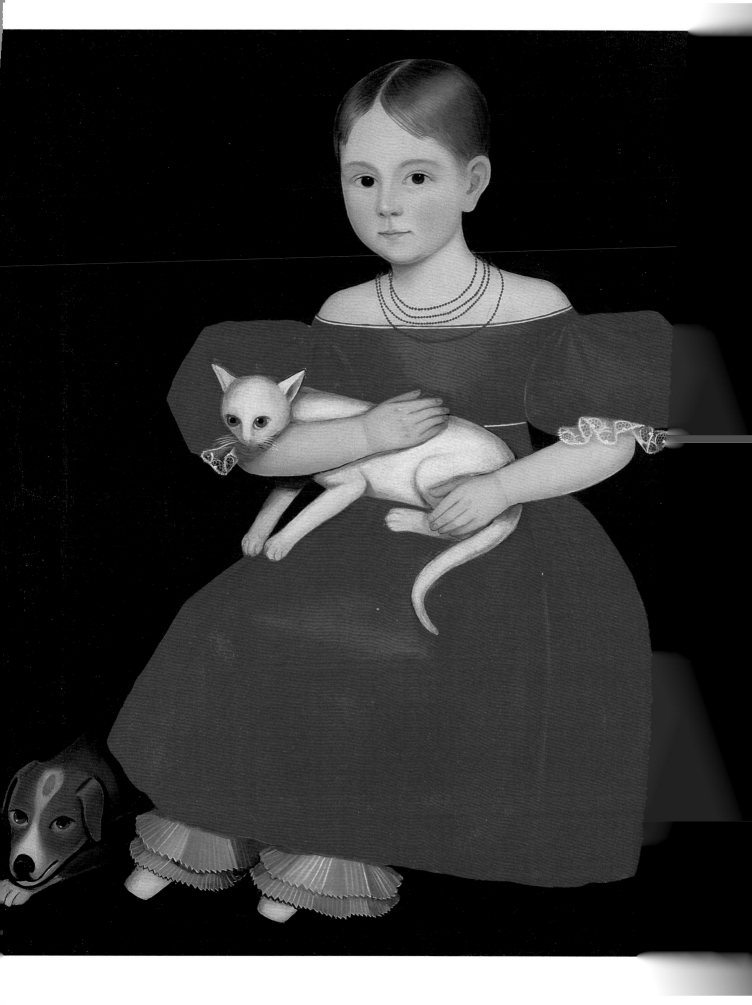

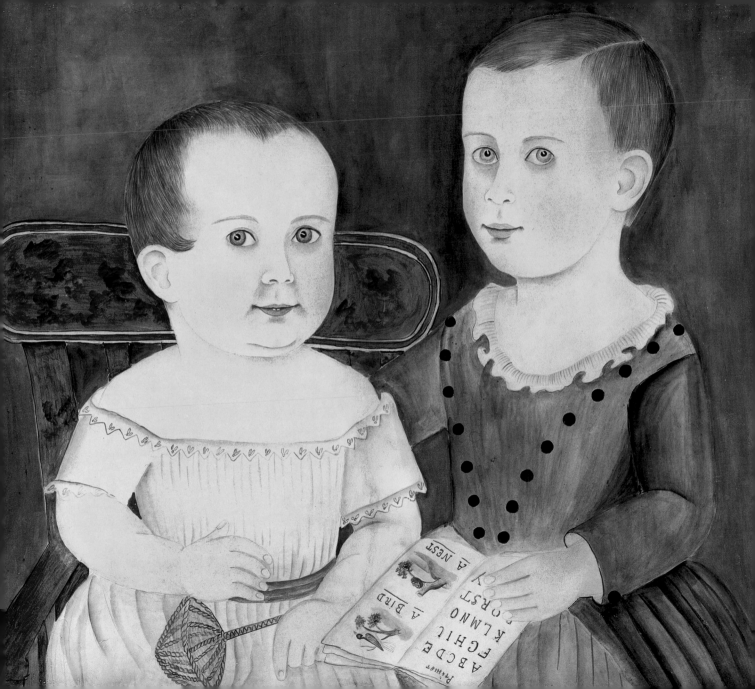

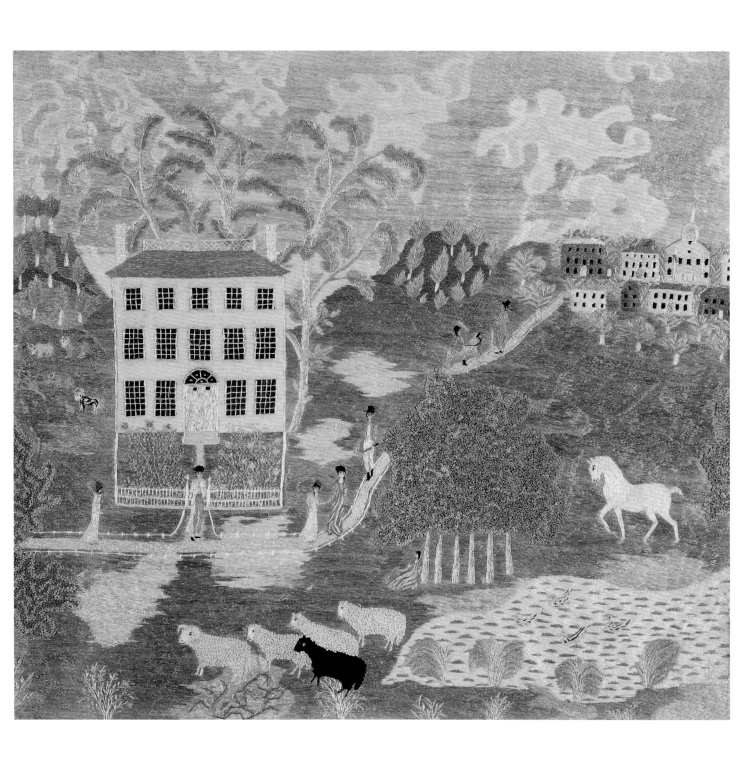

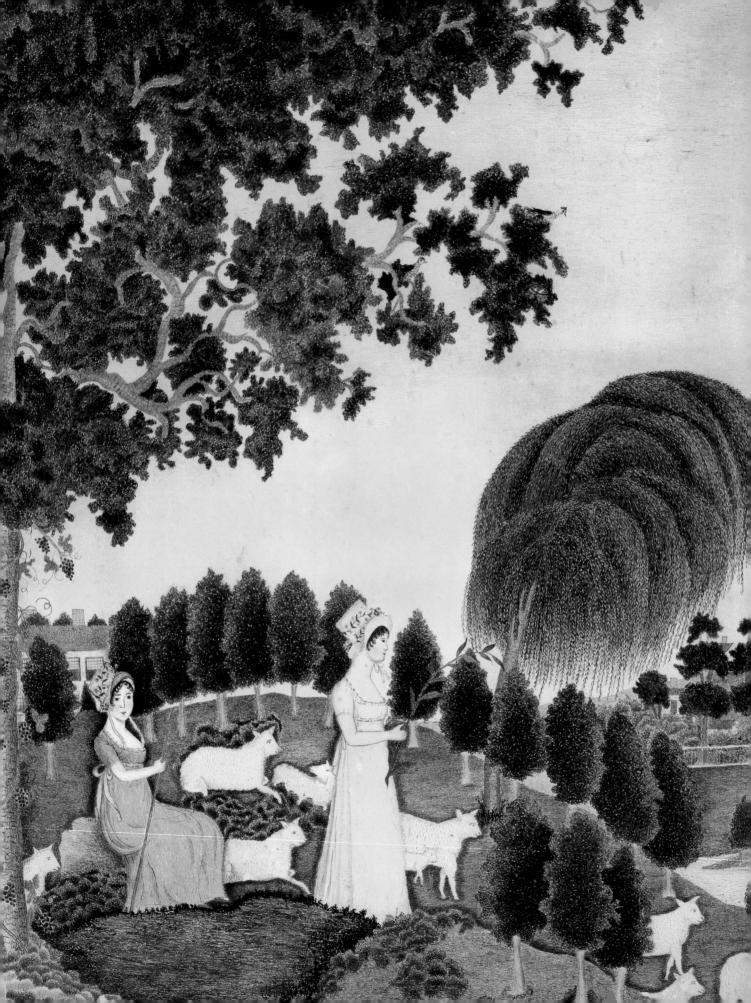

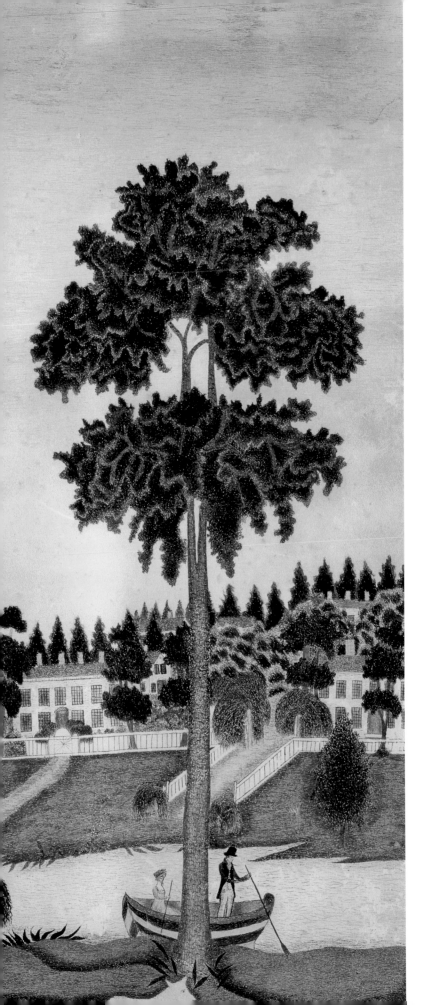

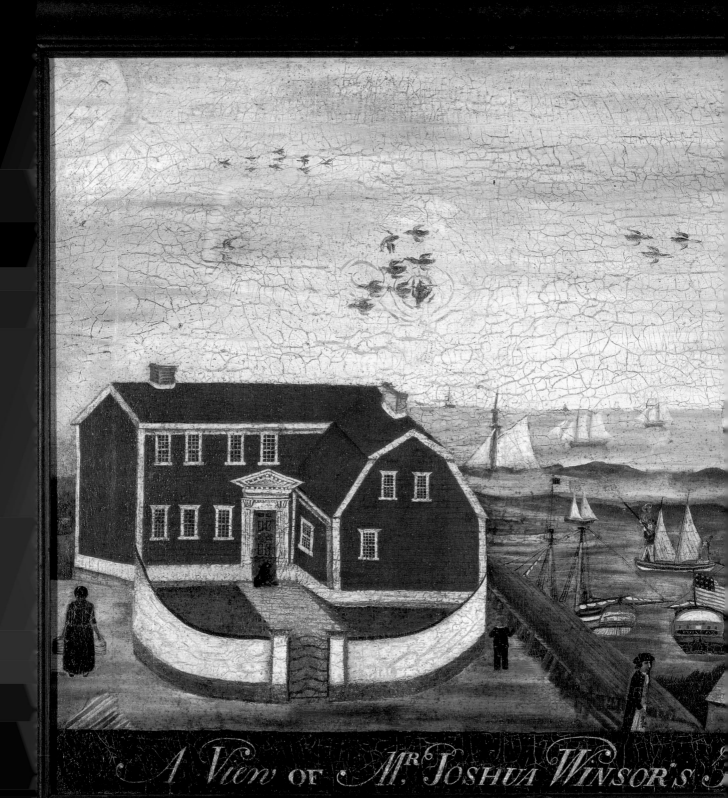

A View of Mr Joshua Winsor's

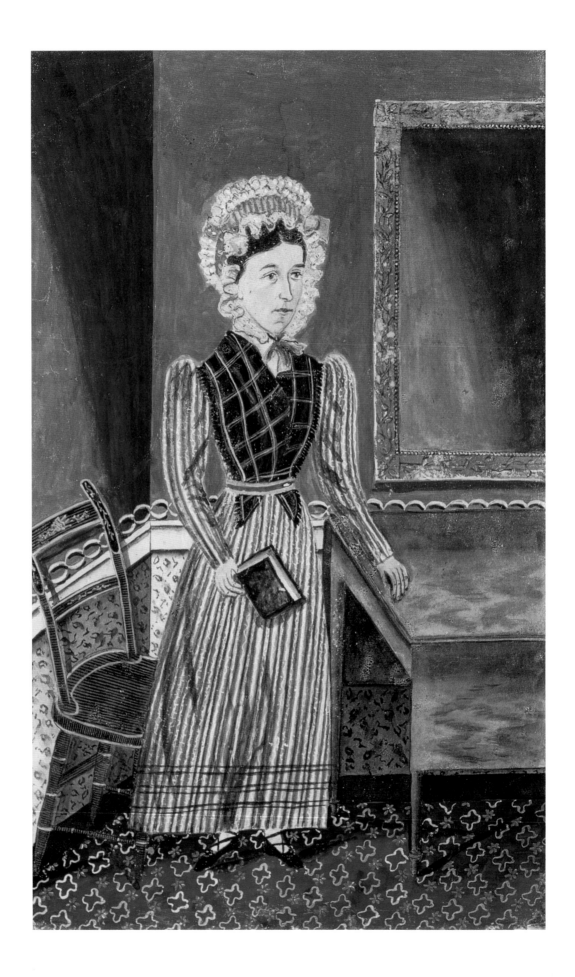

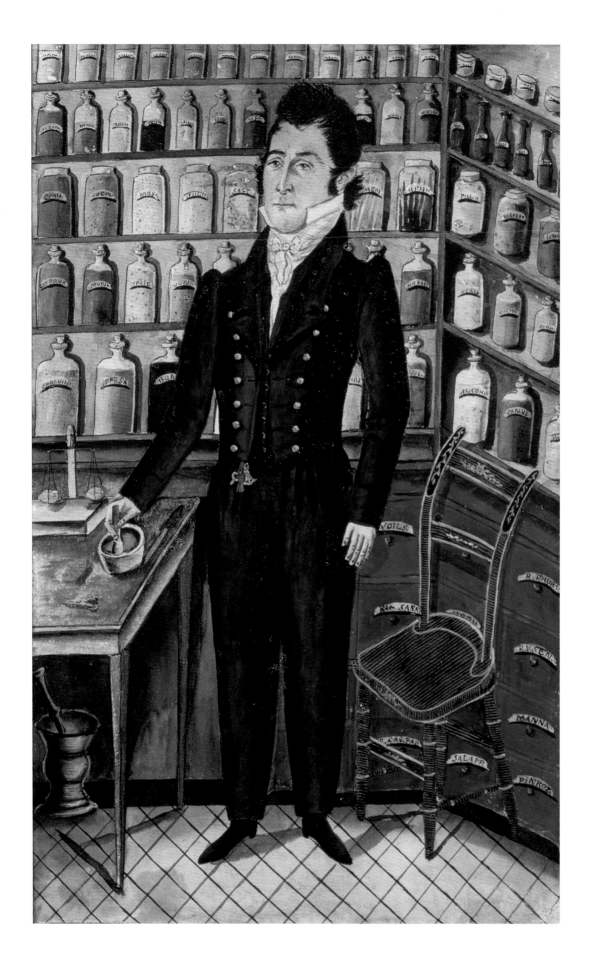

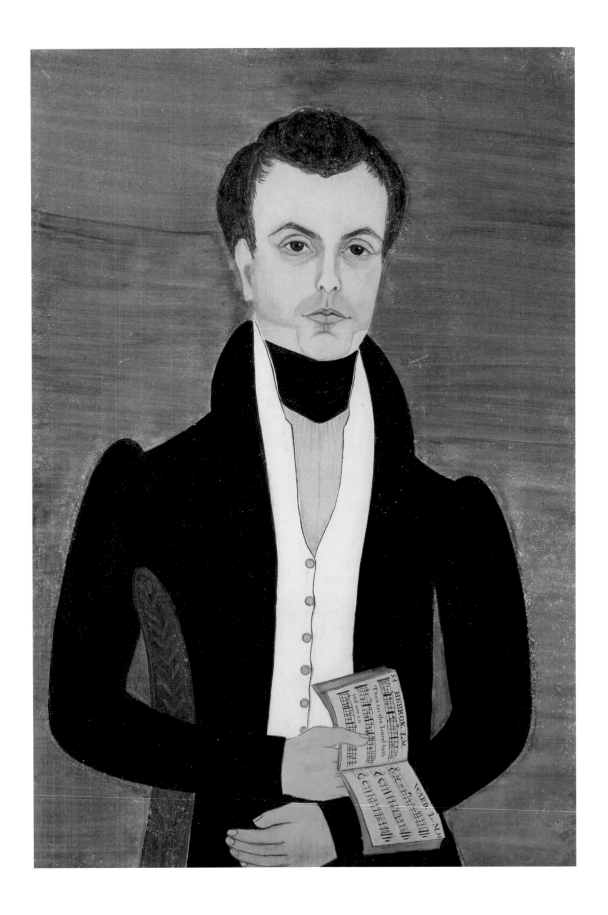

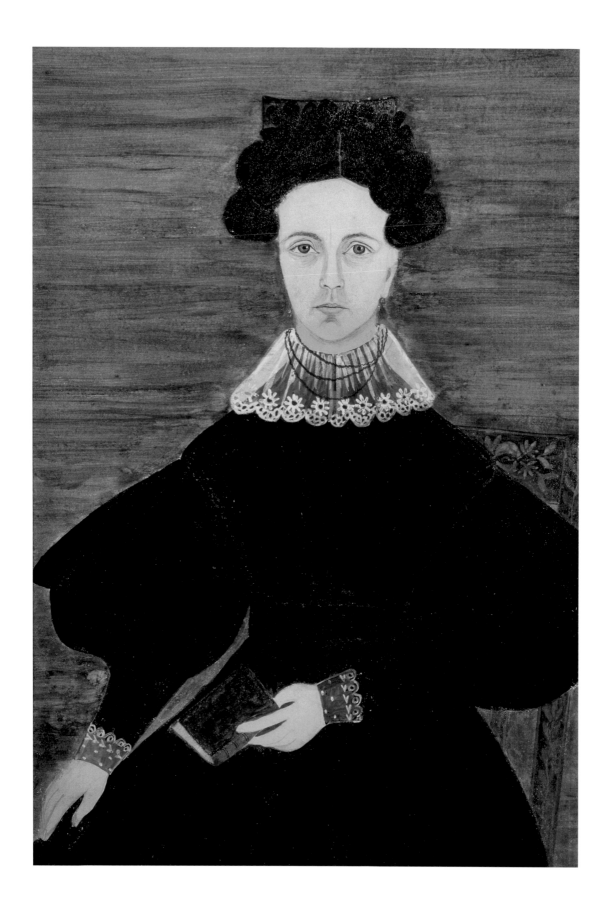

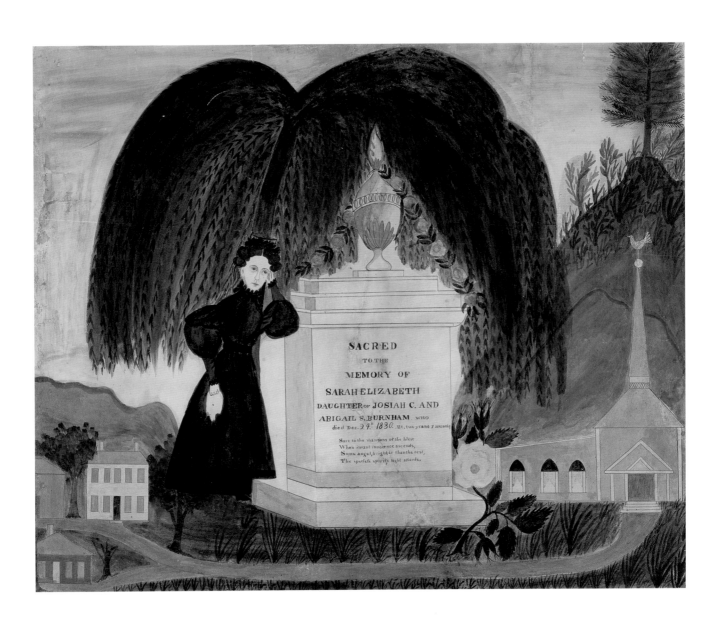

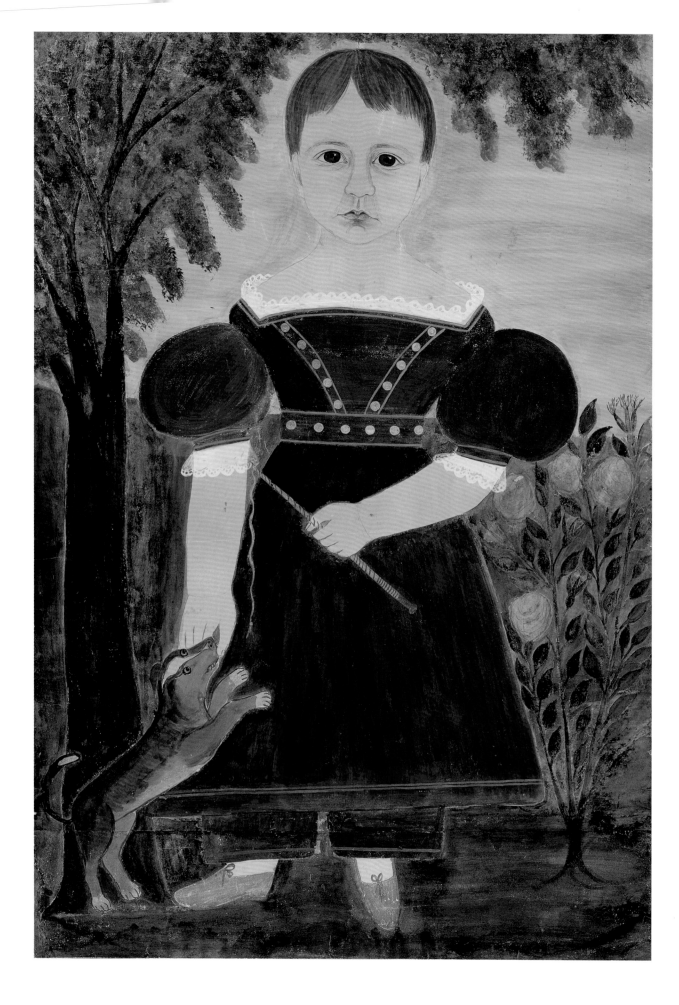

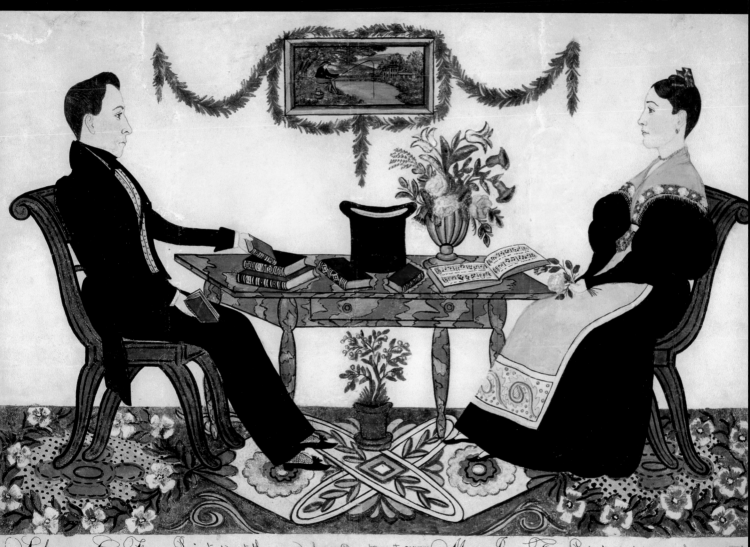

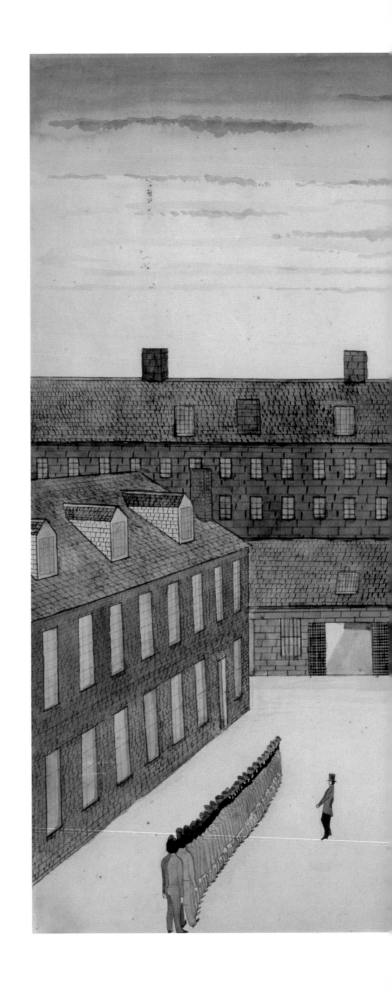

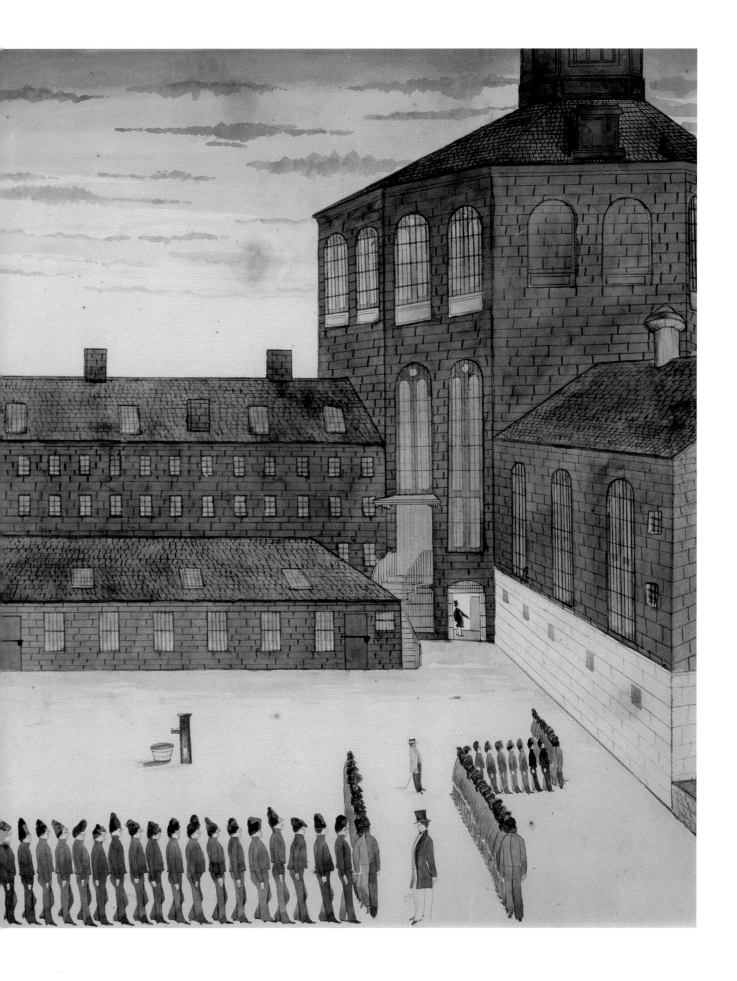

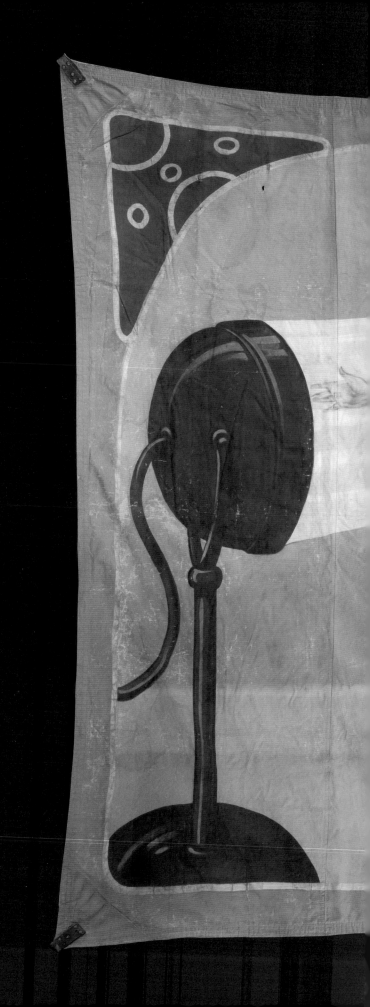

ALIVE

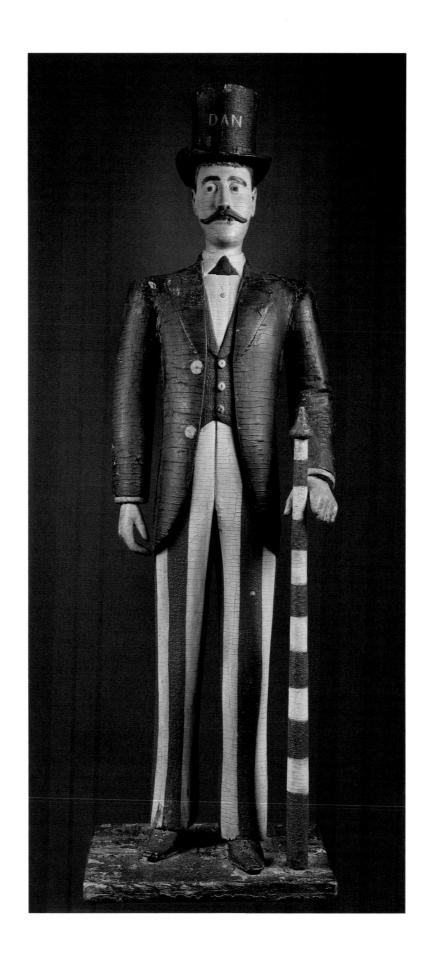

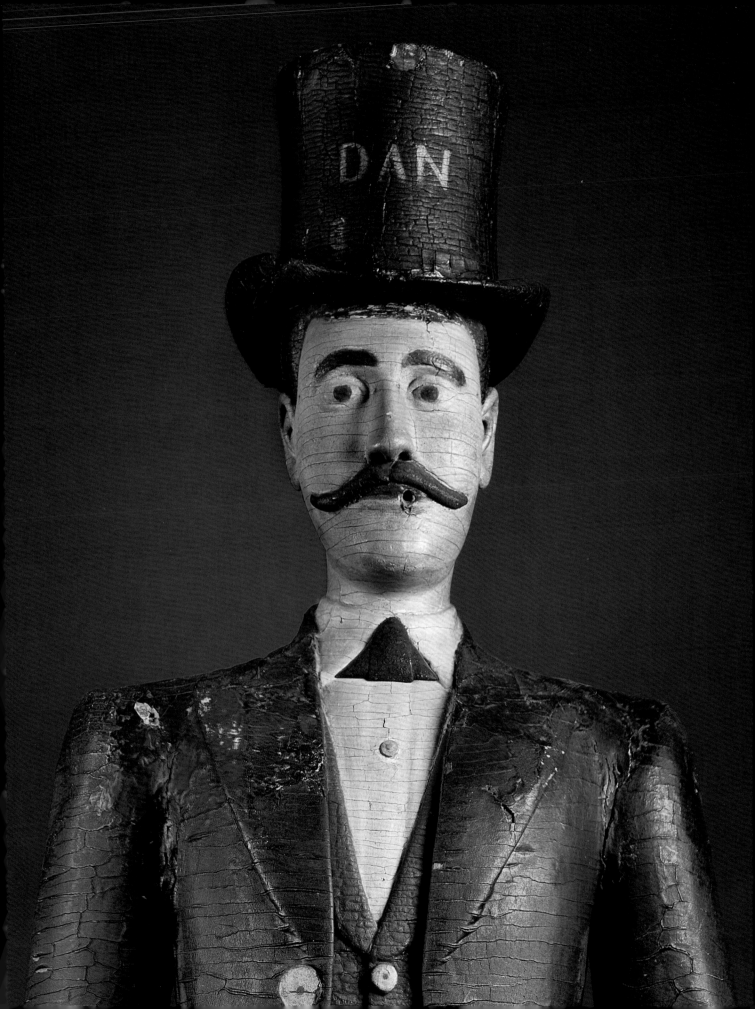

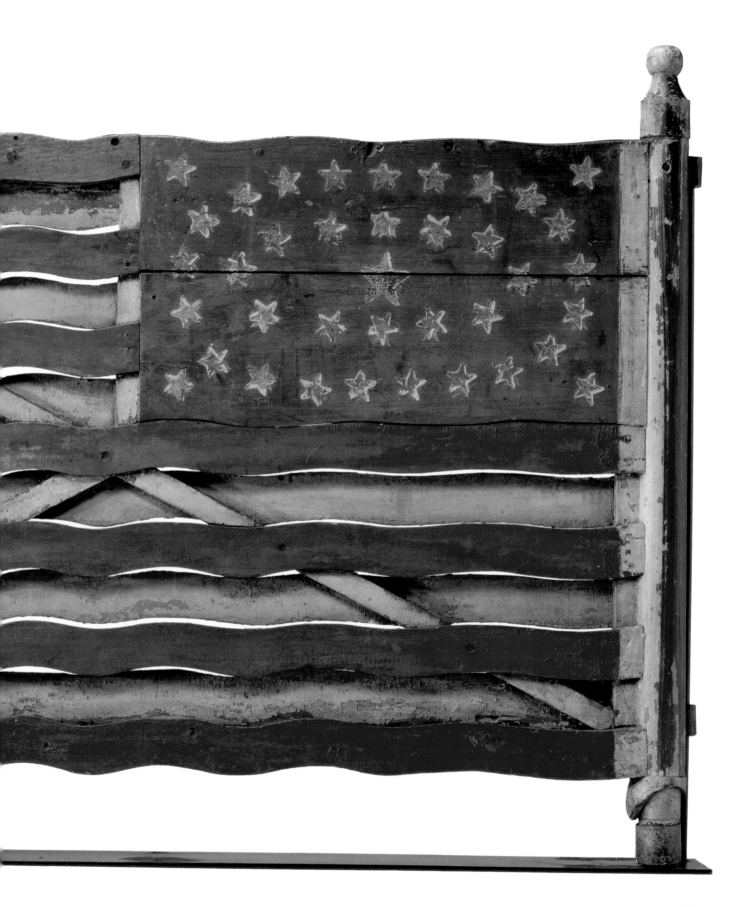

PAGE 157
Liberty Needlework
LUCINA HUDSON (1787–?)
South Hadley, Massachusetts
1808
Watercolor and silk thread on silk, with
metallic thread and spangles
18 × 16"
Museum purchase with funds from the
Jean Lipman Fellows, 1996, 1996.9.1

PAGE 159
Jonathan Knight
ARTIST UNIDENTIFIED
Connecticut
c. 1797
Oil on paperboard, mounted on Masonite
34 × 24"
Gift of Ralph Esmerian, 2005.8.1

PAGE 161
Girl in Red Dress with Cat and Dog
AMMI PHILLIPS (1788–1865)
Vicinity of Amenia, New York
1830–1835
Oil on canvas
30 × 25"
Gift of the Siegman Trust, Ralph Esmerian,
trustee, 2001.37.1

PAGE 163
Learning the ABCs
MARY B. TUCKER (1784–1853)
Massachusetts
c. 1840–1844
Watercolor and pencil on paper
19¼ × 23"
Gift of Ralph Esmerian, 2013.1.15

PAGE 165
Newburyport Needlework Picture
ARTIST UNIDENTIFIED
Newburyport, Massachusetts
c. 1805–1810
Silk on linen
16¼ × 17½"
Gift of Ralph Esmerian, 2013.1.48

PAGES 166–67
River Townscape with Figures
PRUDENCE PERKINS (DATES UNKNOWN)
Possibly Rhode Island
c. 1810
Watercolor on paper
18¼ × 22¼"
Gift of Ralph Esmerian, 2005.8.48

PAGES 168–69
A View of Mr. Joshua Winsor's House &c.
RUFUS HATHAWAY (1770–1822)
Duxbury, Massachusetts
1793–1795
Oil on canvas, in original painted wood frame
28 × 32³⁄₁₆ × 2" (framed)
Gift of Ralph Esmerian, 2013.1.19

PAGE 169
Red-Breasted Merganser Drake and Hen
LOTHROP T. HOLMES (1824–1899)
Kingston, Massachusetts
1860–1870
Paint on wood with glass eyes
9½ × 16 × 6" each
Gift of Adele Earnest, 1994.14.1, 2

PAGES 170–71
Hudsonian Curlew Weathervane
ARTIST UNIDENTIFIED
Seaville, New Jersey
c. 1874
Gold leaf on sheet metal with iron straps
46⅛ × 92¼ × ⅜"
Gift of Alice M. Kaplan, American Folk Art
Museum trustee (1977–1989), 2001.3.2

PAGES 172–73
Mary Valentine Bucher
Dr. Christian Bucher
JACOB MAENTEL (1778–?)
Schaefferstown, Pennsylvania
c. 1825–1830
Watercolor, gouache, ink, and pencil on paper
16½ × 10⅛" (sight); 16½ × 10½" (sight)
Gift of Ralph Esmerian, 2013.1.7, 8

PAGES 174–75
Josiah C. Burnham
Abigail S. Burnham
SAMUEL ADDISON SHUTE (1803–1836) and
RUTH WHITTIER SHUTE (1803–1882)
Probably Lowell, Massachusetts
c. 1831–1832
Watercolor, gouache, pencil, and ink on
paper, with applied gold foil
13½ × 9½" each
Gift of Ralph Esmerian, 2013.1.10, 11

IMPROVEMENT

SHOUT

SCREAM

TEACH

PREACH

CHANGE

TESTIFY

REVOLUTION

ICONOCLAST

ReFORMERS

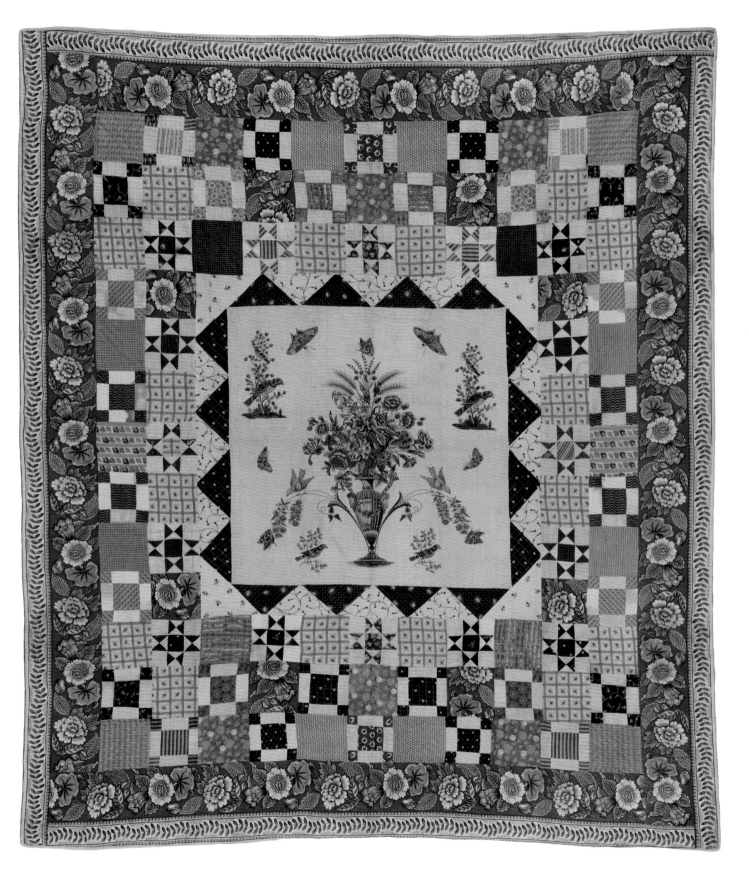

Der Mensch sey hoch weiß reich und
schön, kommt doch die todes stund, heb auf
das blat so wirst du sehn, es ist der
allte bund. ~~~~~~~~

Just du das ander blat auf heben, so
kaust du sehen fein, wie wir nach
diesem kurzem leben, bald aschen
werden sein. ~~~~~~~~

Just du das ander blat auf heben, so
kaust du sehen fein, wie wir nach
diesem kurzem leben, bald aschen
werden sein. ~~~~~~~~

Auf Jesu tod ist alle zeit guth sterben, drauf
wage ichs scheu keine todes noth, es ist
ein gang das leben zu erben, so ist
mein tod nicht mehr ein tod.

Adam kam zu erst auf die welt, wie uns das erst buch Mosis meldt, und wer war dan zu ihm vertraut, heb auf das blat und seh au die braut.

Du auf geblasenes Menschenkind heb auf das blat sieh wie die sünd, deinen heiland ohne gnad, an das Creutz genagelt hat.

Der Mensch sey hoch weiß reich und schön, komt doch die todes stund, heb auf das blat so wirst du sehn, es ist der allte bund.

Wen der Mensch einmahl in Paradeises stand, so komt er bald darnach zum berg Zion genant, heb auf das blat so wirst du sehn, wie dort die reinen geister stehn.

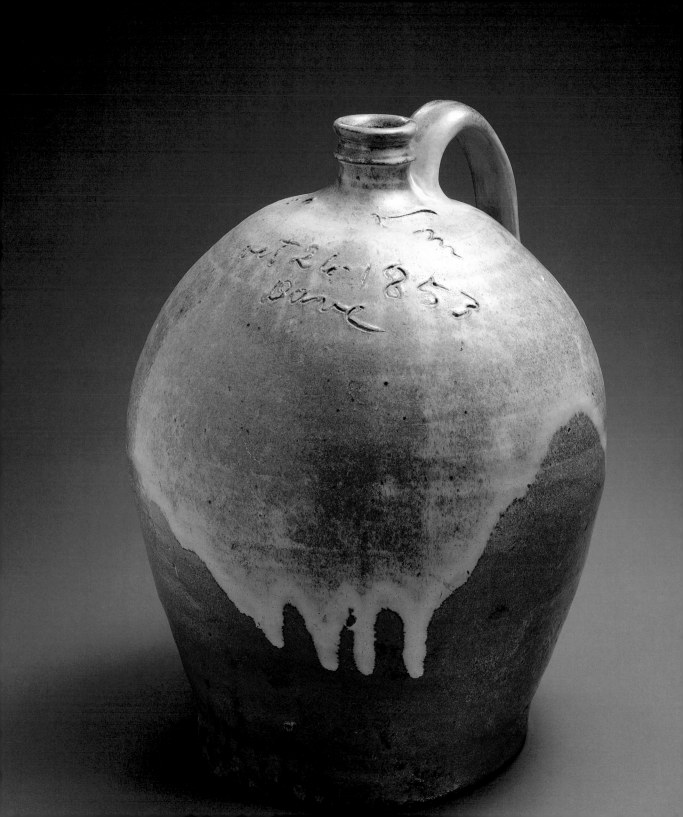

Prisoners Cookhouse Point-Lookout Md

Capt A. W. Barnes. Ass't Prov Marshal.
Point-Lookout-Md.

"Git-away from dat-dar fence white man, or I'll make
Old Abes gun smoke at you, I can hardly hold de ball back
now." De bottom rails on Top now.

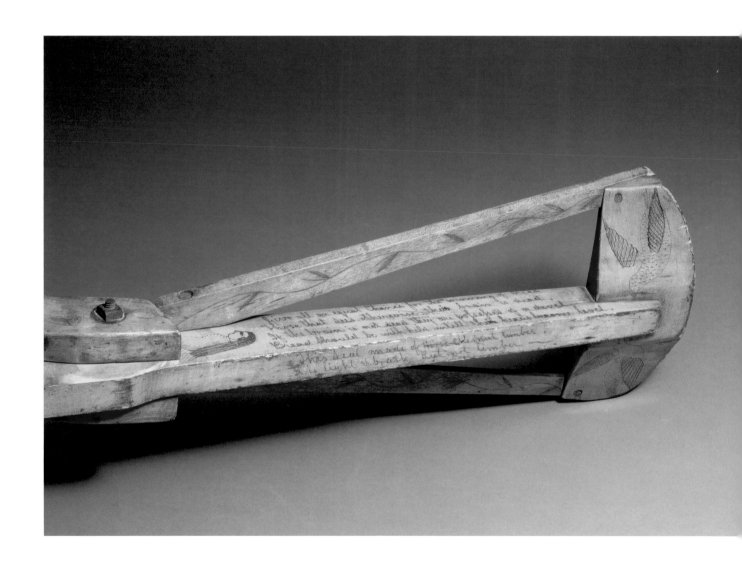

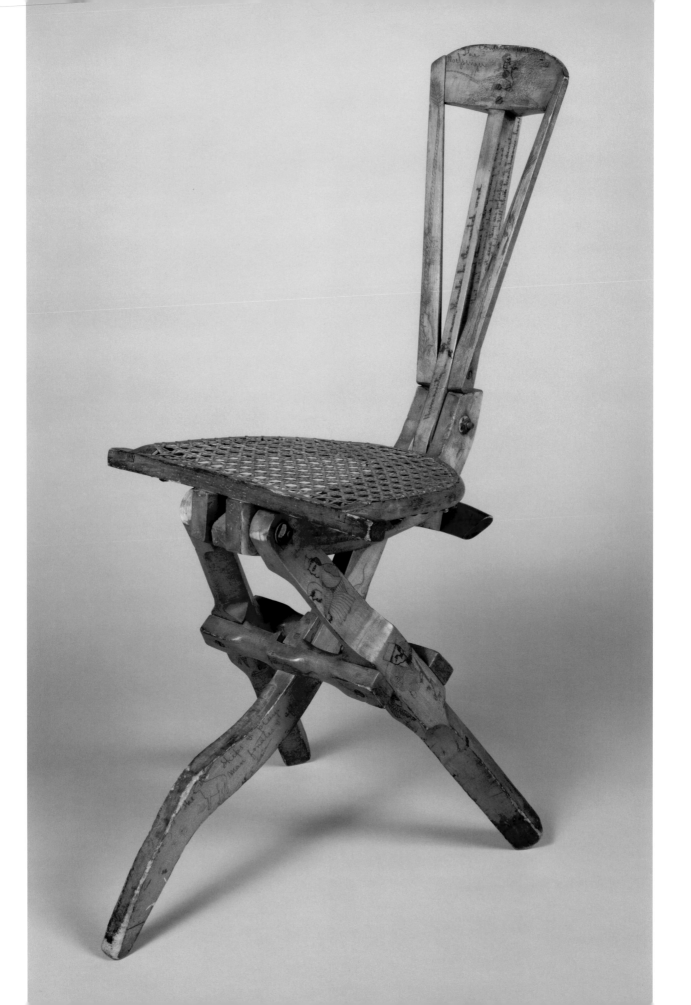

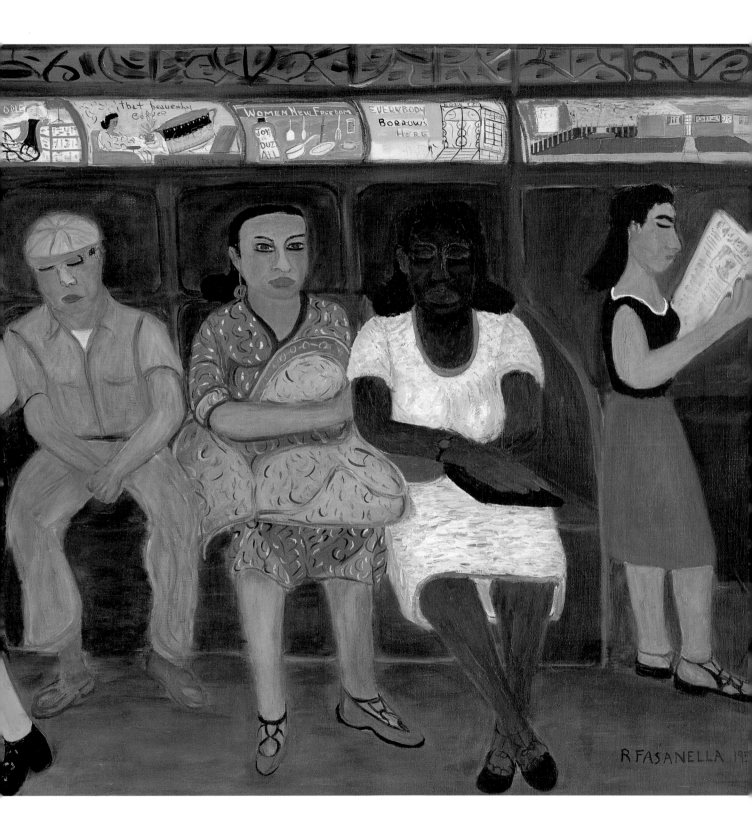

ROCKING
MARY

SAM DOYLE

FULTON. MO. SEPT. 24. 1976.
FREE THOUGHT, AND FREE SPEECH! AND
JESSE HOWARD IS MY NAME. AND I WILL SWEAR
IN TRUTH. UNTO DAVID, AND THE REST
OF THE WORLD." SEE "PSALM S: 132 = 11.
SEE, THE 19 CHAPTER, OF THE BOOK OF JOB! YOU,
YES, YOU, WILL FIND THIS WRITEING. QUOTE." "
MY KINFOLK'S HAVE FAILED, AND, MY FAMILIR
FRIEND'S HAVE FORGOTTEN ME." THEY THAT
DWELL IN MINE HOUSE AND, MAID'S COUNT ME
FOR A STRANGER: I AM AN ALIEN IN THEIR SIGHT,
I CALLED MY SERVANT, AND HE GAVE ME
NO ANSWER! JOB. 19 = 16. READ ON. VERSE. 17. QUO.
MY BREATH IS STRANGE TO MY WIFE. THOUGH
I INTREATED FOR THE CHILDREN'S SAKE
OF MINE OWN BODY. VERSE, 18. QUOTE. YEA.
YOUNG CHILDREN, DSPISED ME: I AROSE. AND
THEY SPAKE AGAINST ME. VERSE. 19. QUOTE."
ALL MY INWARD FRIEND'S ABHORED ME:
AND THEY WHOM I LOVED ARE TURNED
AGAINST ME." READ ON AND ON."
YES. WHEN. YOU, YES, YOU HAVE READ,
THE WHOLE BOOK OF JOB: YOU HAVE."
READ 42 "CHAPTER S: 1.070. VERSES!
10.102 WORD'S!
JESSE HOWARD. THE MAN WITH MANY
SIGN'S AND WONDEDERERS."

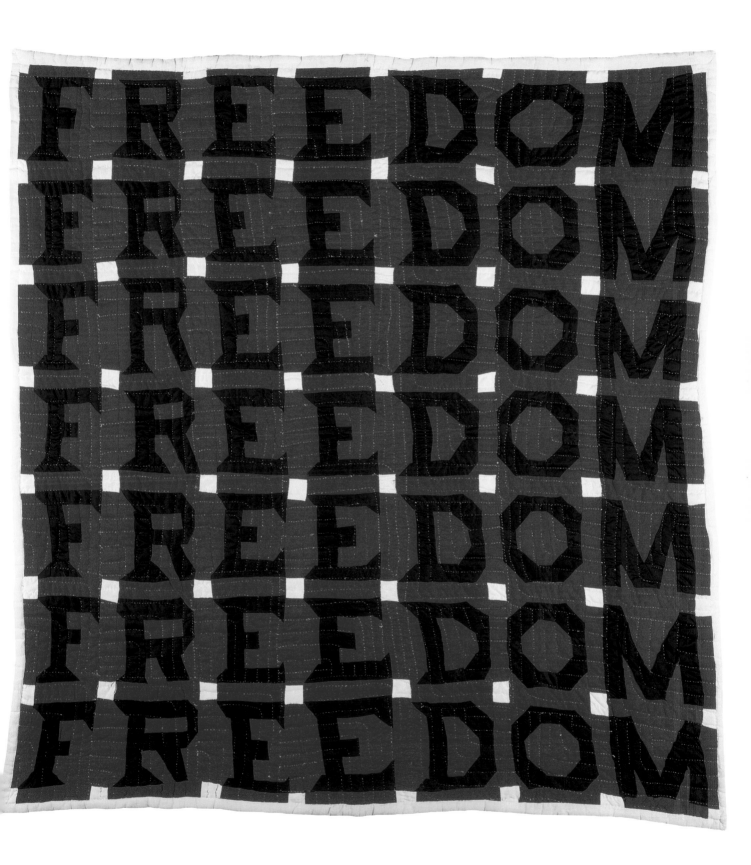

221

REFORMERS

INVENTION

INNOVATION

MECHANICAL GENIUS

DISPLACEMENT

RELOCATION

SYNTHESIS

ADAPTATION

BRICOLAGE

INGENUiTY

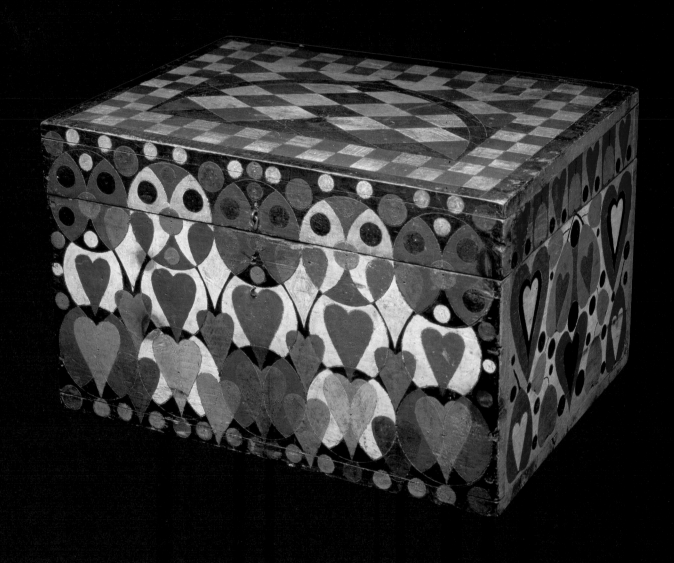

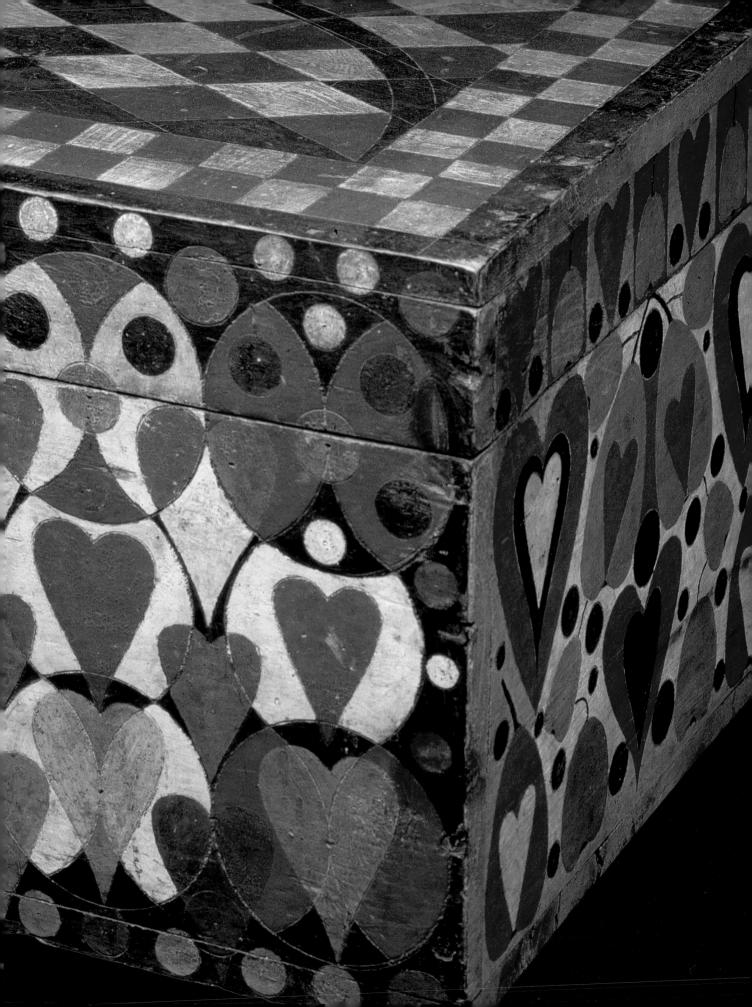

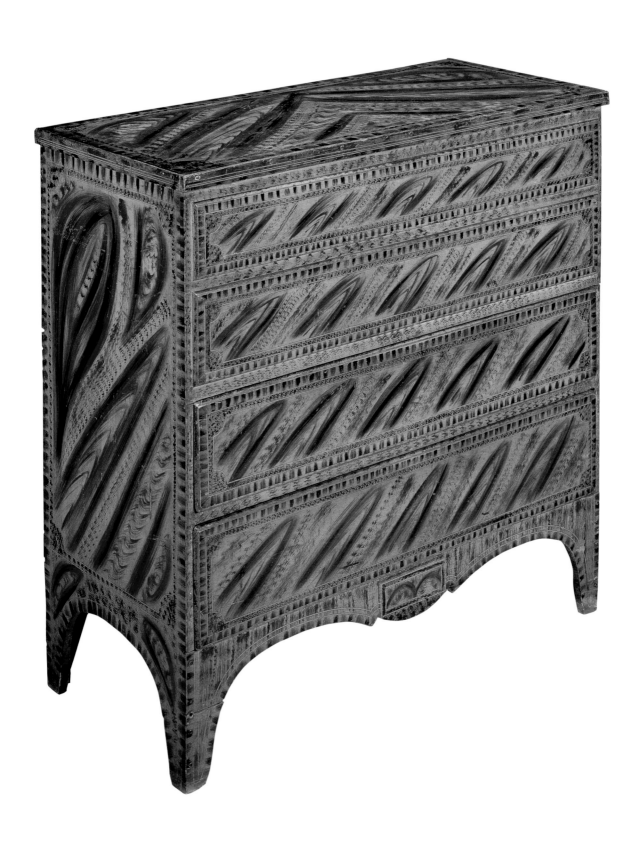

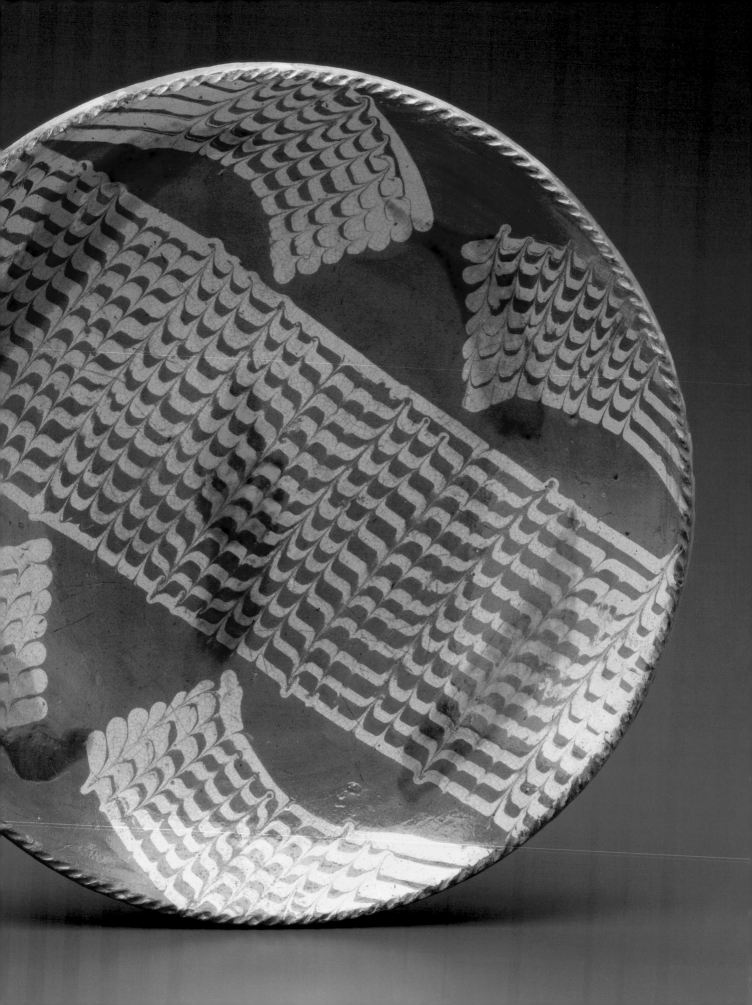

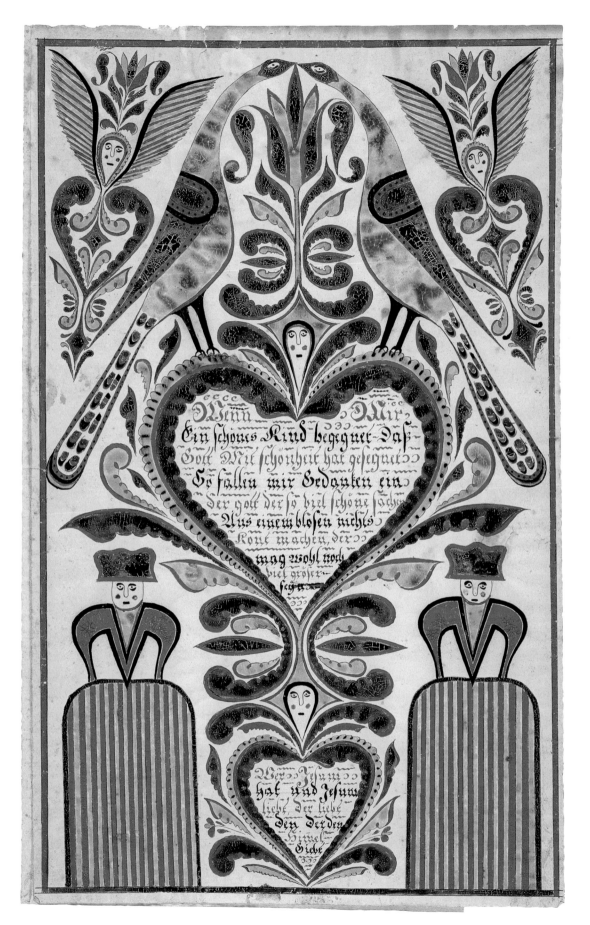

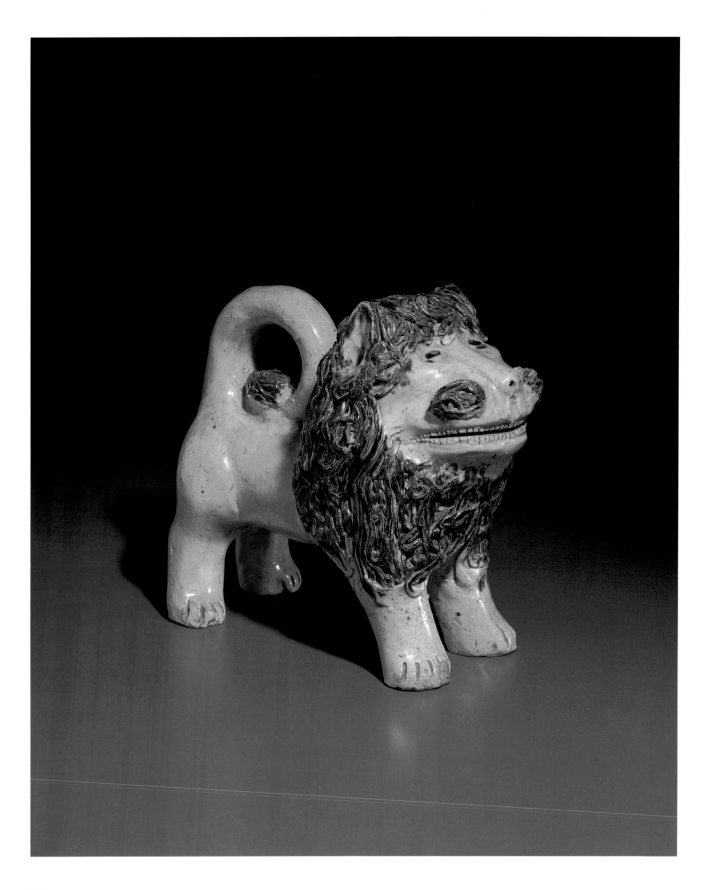

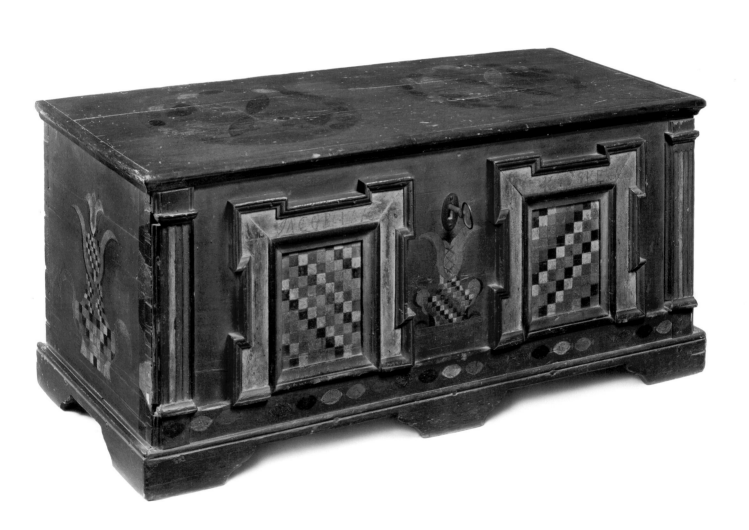

244

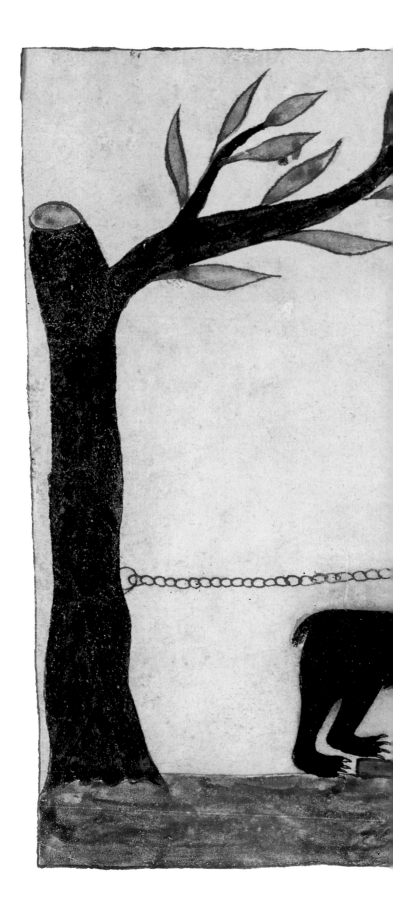

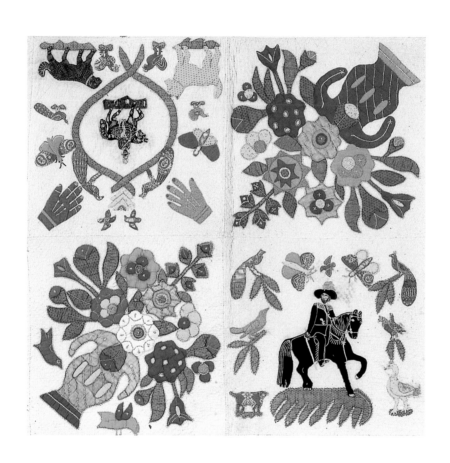

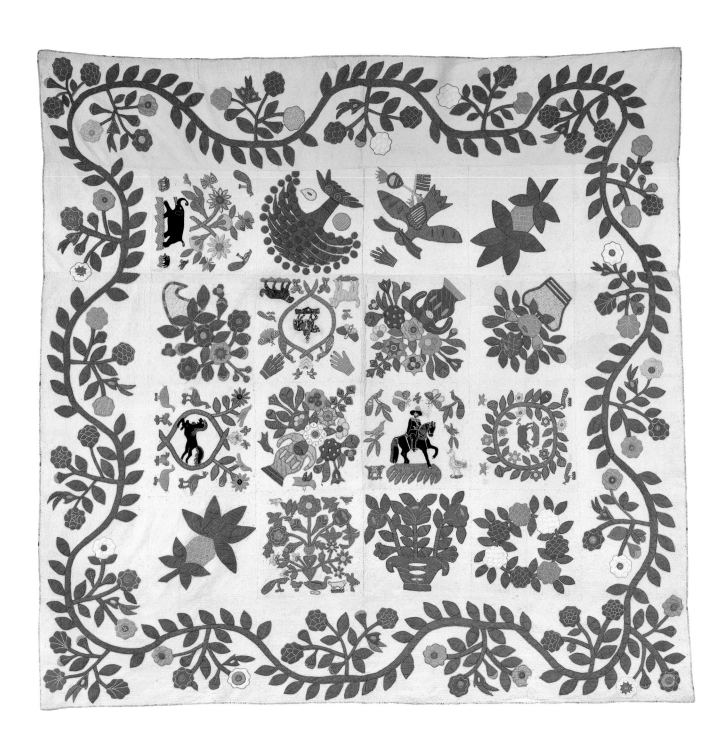

INGENUITY

TRANSITION

MILESTONES

RITES OF PASSAGE

ALTERED STATES

APOTHEOSIS

PASSENGERS

VOYAGERS

EXPLORERS

GUiDES

259

May 22d 1811

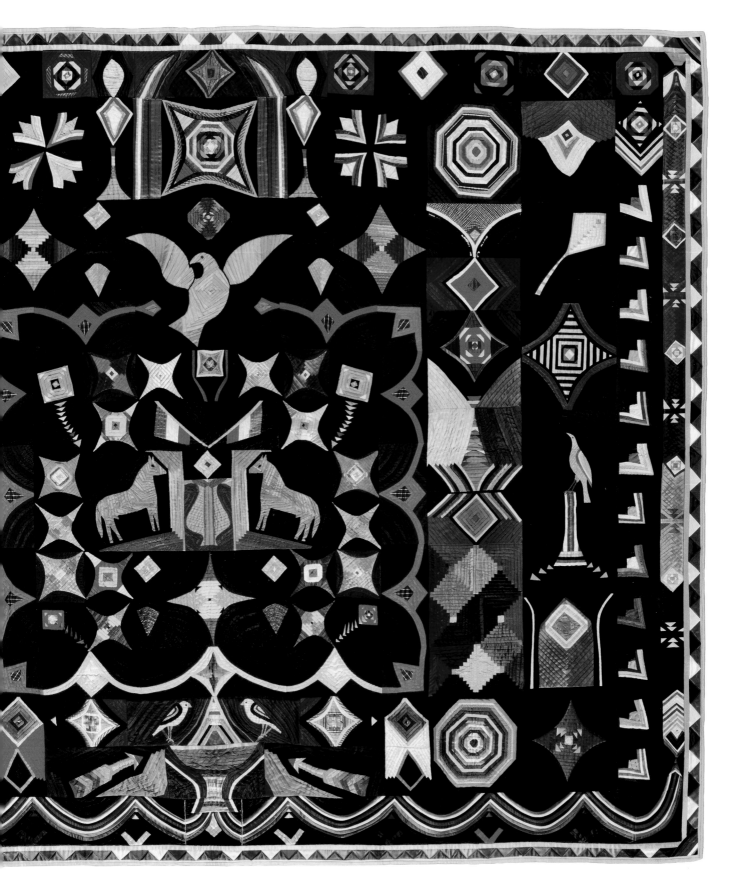

267

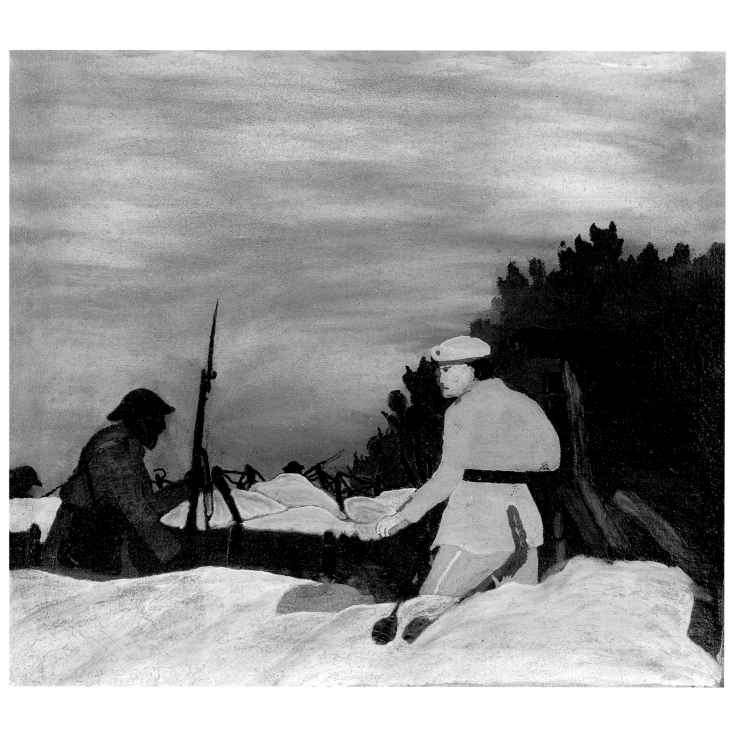

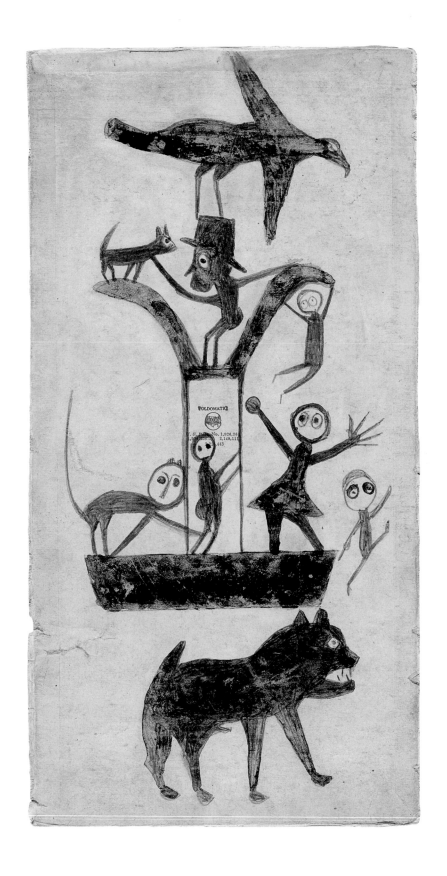

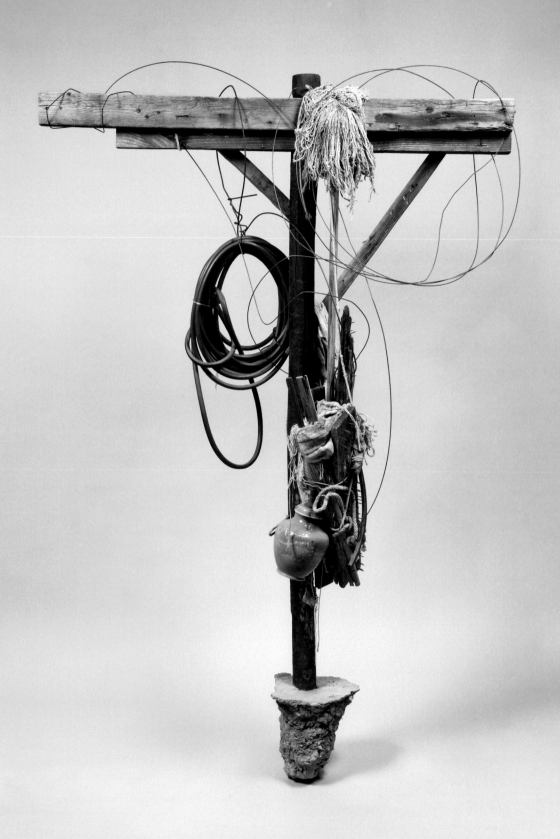

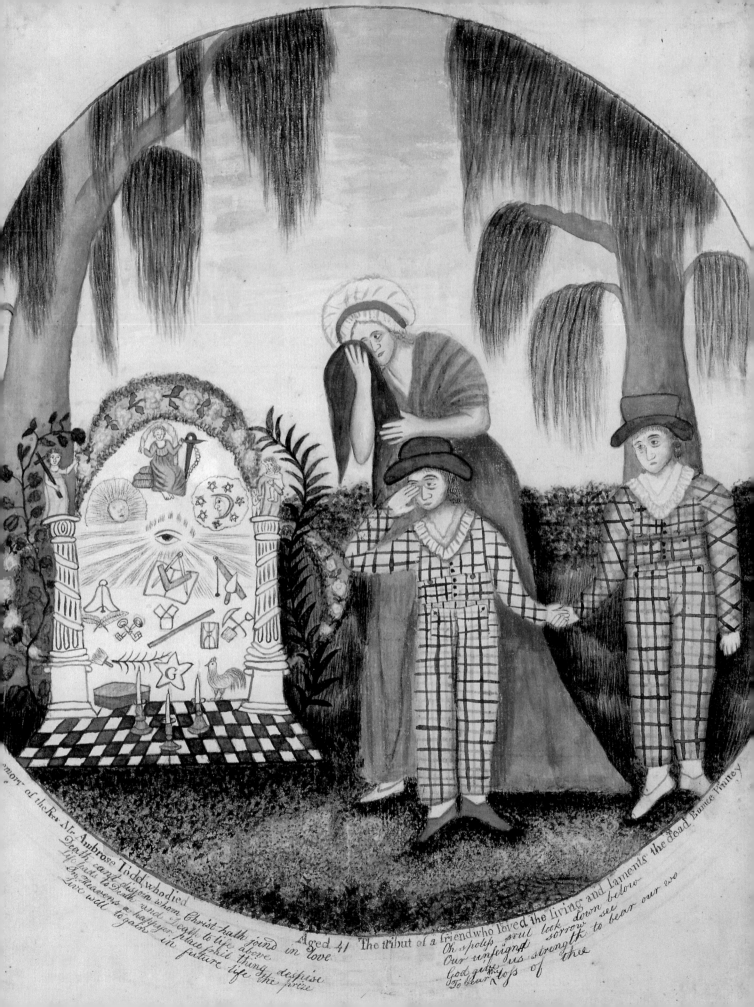

mory of the Rev.r Mr Ambrose Todd who died _Aged 41_ The tribut of a friend who loved the living and laments the dead _Eunice Piney_
Death cant ___ the person whom Christ hath joind in love Oh spoliß ____ soul look down below see
_He fails to Reath. and _ Death to life life aboves Our unfeigne ____ sorrow see
In Heavens a happyer place his thing _despise God giv ___ us strength to bear our wo
Live well to gain __ in future life the prize To bear __ loss of ____ thee

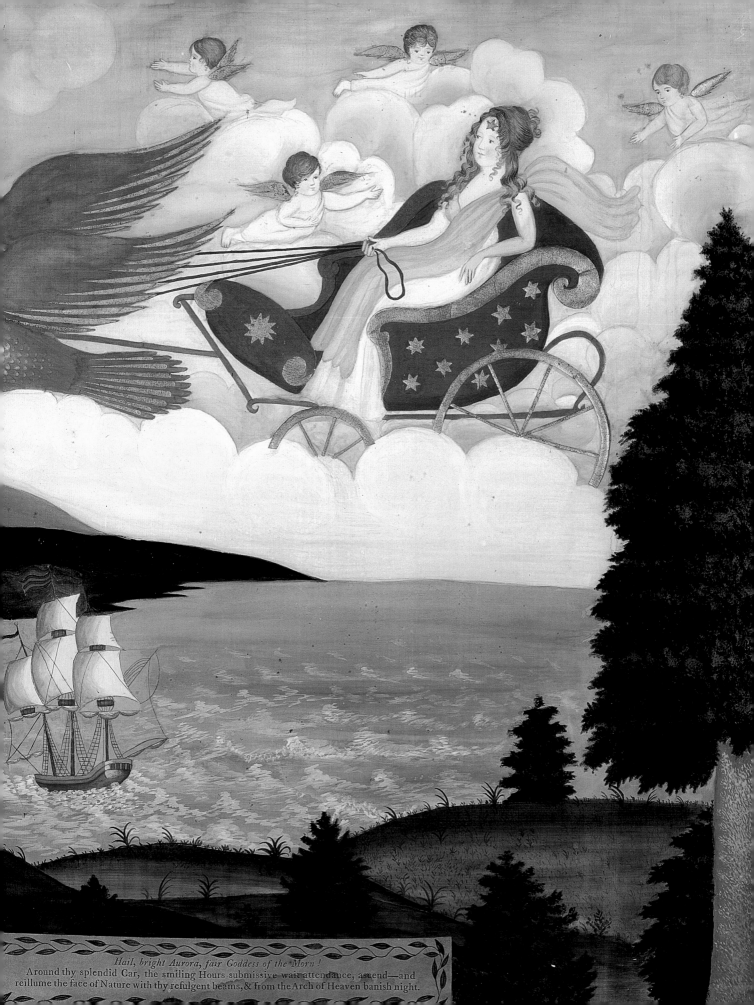

Hail, bright Aurora, fair Goddess of the Morn!
Around thy splendid Car, the smiling Hours submissive wait attendance, ascend—and reillume the face of Nature with thy refulgent beams, & from the Arch of Heaven banish night.

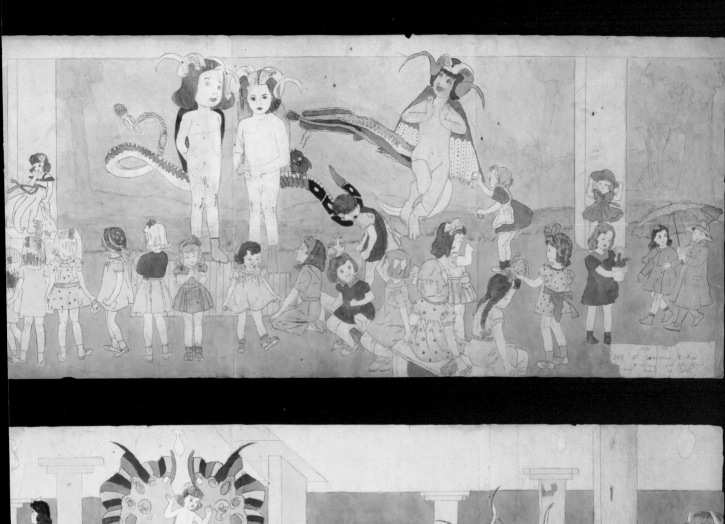
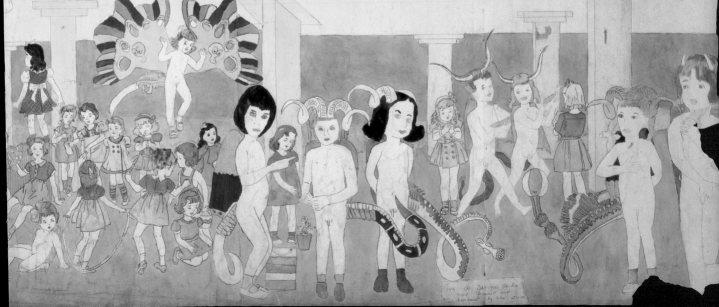

GUIDES

CONTRIBUTORS

Stacy C. Hollander is Deputy Director for Curatorial Affairs, Chief Curator, and Director of Exhibitions at the American Folk Art Museum. She has served as curator of numerous exhibitions for the museum, including *Compass: Folk Art in Four Directions* (2012), *Women Only: Folk Art by Female Hands* (2010), *The Seduction of Light: Mark Rothko | Ammi Phillips: Compositions in Pink, Green, and Red* (2008), and *Asa Ames: Occupation Sculpturing* (2008); as co-curator of *Traylor in Motion: Wonders from New York Collections* (2013) and *Revisiting Ammi Phillips: Fifty Years of American Portraiture* (1994); and as project coordinator of *Infinite Variety: Three Centuries of Red and White Quilts* (2011). Selected writings as author and coauthor include *Harry Lieberman: A Journey of Remembrance* (1991), *American Radiance: The Ralph Esmerian Gift to the American Folk Art Museum* (2001), and *American Anthem: Masterworks from the American Folk Art Museum* (2001). Hollander has also published on a wide range of folk art topics in magazines, scholarly journals, catalogs, and encyclopedias, and has lectured in the United States and abroad. Hollander received her BA from Barnard College, Columbia University, and her MA in American folk art studies from New York University.

The Honorable **Anne-Imelda Radice**, PhD, is Executive Director of the American Folk Art Museum. Dr. Radice is a member of the Association of Art Museum Directors and is the former head of the Institute of Museum and Library Services, where she served under both President George W. Bush and President Barack Obama. Prior to joining the IMLS, she held leadership positions at the National Endowment for the Arts, the National Endowment for the Humanities, and the Department of Education, and she was the first director at the National Museum of Women in the Arts, Washington, DC. She is a recipient of the Presidential Citizens Medal (2008), the Forbes Medal (2008), and Heritage Preservation's Heritage Defender Award (2009). She holds a PhD from the University of North Carolina, Chapel Hill; an MBA from American University; an MA from the Villa Schifanoia, Florence, Italy; and an AB from Wheaton College.

Valérie Rousseau, PhD, has served as Curator, Art of the Self-Taught and Art Brut, at the American Folk Art Museum since 2013, where she cocurated the exhibition *Traylor in Motion: Wonders from New York Collections* (2013) and coordinated the symposium *Bill Traylor: Beyond the Figure* (2013) and its proceedings (2014). As a founding director of the Société des arts indisciplinés in Montréal, she created an archive center on self-taught artists and developed many projects, notably the international symposium *Indiscipline & Marginalité* (2003). She has curated the exhibitions *Collectors of Skies* and *Henry Darger* (Andrew Edlin Gallery, New York, 2012 and 2010), *Richard Greaves: Anarchitect* (Darling Foundry, Montréal, 2005; Collection de l'Art Brut, Lausanne, Switzerland, 2006; Art & Marges Museum and CIVA, Brussels, 2007), and *Bill Anhang* (Saidye Bronfman Centre for the Arts, Montréal, 2003). She has been is involved in exhibitions, studies, lectures, and publications in anthropology, including *Culture & Musées* (2010), and on artists such as ACM, James Castle, Guo Fengyi, Paul Laffoley, A. G. Rizzoli, Sava Sekulić, Palmerino Sorgente, Marcel Storr, and George Widener. She is the author of "Visionary Architectures" (in *The Alternative Guide to the Universe*, Hayward Gallery, 2013), and *Vestiges de l'indiscipline* (Canadian Museum of Civilization, Gatineau, Quebec, 2007). Since 2012 she has been the program director of the Outsider Art Fair (New York and Paris). An affiliated researcher at the LAHIC (iiAC-CNRS, Paris), she currently serves on the International Committee of the College Art Association.

INDEX

PHOTOGRAPHY